In Memory of

Richard Knowles

Distinguished Emeritus
Art Department
University of Memphis

2018

JEAN COCTEAU
DRAWINGS

129 DRAWINGS FROM
"DESSINS"

WITH A NEW FOREWORD BY
EDOUARD DERMIT

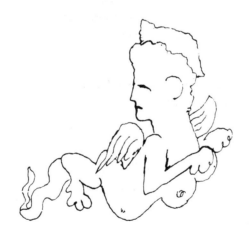

DOVER PUBLICATIONS, INC.
NEW YORK

This Dover edition, first published in 1972, is an unabridged republication of the third edition (1924) of the book "Dessins," originally published in 1923 by the Librairie Stock (Delamain, Boutelleau et Cⁱᵉ), Paris. A new Foreword has been written specially for the present edition by Edouard Dermit. This Foreword and all the original text (dedication and captions) have been newly translated by Stanley Appelbaum, who also supplied the brief explanatory notes.

International Standard Book Number: 0-486-20781-1
Library of Congress Catalog Card Number: 78-182100

Manufactured in the United States of America
Dover Publications, Inc.
180 Varick Street
New York, N.Y. 10014

FOREWORD

Born into an art-loving middle-class family, Jean Cocteau was blessed, among other talents, with that of draftsmanship. For, unlike every other artist worthy of the name, he never attended the Beaux-Arts or any other academy or school. He exercised his gift for drawing from his earliest years, and throughout his life he drew as much as he wrote. His graphic œuvre, though little known, is extensive.

Jean Cocteau justified his passion for drawing with this axiom: he considered drawing to be a handwriting which was untied and then retied in a different fashion. When he had to execute a portrait, it was necessary for the model to be imprinted on his mind, so that he no longer had to think of it but could let his hand be freely guided by his subconscious. Otherwise—if tempted in the least to think, to try to make a correction with the aid of his reason—he was sure that his drawing would be a failure, that it would not live that life of its own without which a work of art is not a success.

This album, published in 1923, represents the first collection and publication of drawings by Jean Cocteau. It is the only one, I believe, published purely for the sake of the drawings, without a text, allowing the handwriting of the draftsmanship to speak for itself. Subsequently he illustrated several of his books, and a number of reproductions of his drawings are to be found in exhibition catalogues. In closing, I would like to quote a few reflections by Jean Cocteau on his conception of the art of painting.

> From the preface to an exhibition: "I am neither a draftsman nor a painter. . . . As far as painting is concerned, it is the act of painting that I like. It requires no intermediaries other than the hand and the eye. . . . I conceive a picture mentally, and I try to copy this conception as faithfully as possible. I keep at it until the mental vision separates itself from me and lives a life of its own."
>
> August 28, 1951: "It would be insane to write or paint for other people . . . but from time to time our works are discovered by people who would have liked to write or paint them, and that creates a family for you in the world outside. The only excuse for art is that it makes friends for us."
>
> July 28, 1962: "I relax from writing by working with my hands, by painting or drawing; I relax from painting by writing . . . as if drawing were anything other than handwriting retied differently."
>
> August 2, 1962: "What still surprises me is not merely that I executed this work in which I would make no changes today, but also the penumbra that welcomes you, and my characters who gradually detach themselves from the walls and vaults when the eye grows accustomed to the place. It is like being inside a pearl that has an internal luster, with light produced by the décor.

"A lack of imagination prevents people from seeing things as they will be. They see only things as they are. It is this blindness that would trammel us if we listened to the public and the judges. Our task consists in finding the ultimate solution for what we have decided to do."

December 22, 1960: "New pastel this morning. Every time I rediscover my path, whatever it may happen to be, I seem to have been touched by a miracle—I am lifted from the ground and take leave of myself to become the thing I am creating. Nothing can be compared to this intoxication with work, and I wonder if the saddest of all misfortunes is not that of being incapable of such orgies."

EDOUARD DERMIT

Milly-la-Forêt
November 3, 1971

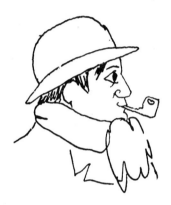

DEDICATION TO
Picasso

Poets don't draw. They untie handwriting and then knot it up again in a different way.

That's why I take the liberty of dedicating to you a few downstrokes made on blotters, tablecloths and backs of envelopes. Without your advice I would never have dared to assemble them.

vi

LIST OF ILLUSTRATIONS

NOTES TO THE ILLUSTRATIONS

1–4 Anna de Noailles (1876–1933), society woman, poet, friend of Cocteau in the years around 1910.

5 In 1917 Satie (1866-1925) had written the music for the ballet "Parade" to Cocteau's libretto.

6–8 Auric (born 1899) was one of the composers in the "Groupe des Six" organized by Cocteau in 1918; all six wrote music to texts by Cocteau in the early twenties. Auric was later to write the background music of Cocteau's films.

9/10 Poulenc (1899–1963) was another of the "Groupe des Six." In 1959 he was to turn Cocteau's play "La Voix humaine" into an opera. The drawing No. 9 was done in 1922.

12 Picasso became Cocteau's lifelong friend in 1915; Cocteau considered the painter's life and work one of the greatest influences on his own creativity.

13–20 Radiguet, the author of "Devil in the Flesh," died at the age of nineteen at the end of 1923, the very year in which this book was first published. He was a friend and protégé of Cocteau; they met in 1919, and were inseparable from then on. The drawings of Radiguet sleeping were done in the summer of 1922, while Cocteau was working on his long poem "Plain-Chant." This poem includes many passages about the slumber of the loved one, a theme to which Cocteau often recurred in his writings and his drawings.

22/23 Bakst (1866–1924) was the chief designer attached to Diaghilev's Ballets Russes. He had done the costumes and sets for Cocteau's first theatrical work, the ballet "Le Dieu bleu" (The Blue God), in 1912.

24 Koubitzky was a singer who performed with the "Groupe des Six" in 1919 and 1920.

25 Hugo had already designed the costumes and masks for Cocteau's ballet (with spoken text) "Les Mariés de la Tour Eiffel" (The Wedding Party on the Eiffel Tower), 1921, and was to do sets and costumes for other stage works by Cocteau.

27 A pun on "association football," i.e. soccer.

48 A reference to the famous rhapsody "España" by the composer Emmanuel Chabrier.

49–57 Cocteau was closely connected with Diaghilev's Ballets Russes from 1911 into the twenties. The great Nijinsky danced in Cocteau's "Le Dieu bleu" in 1912. "Schéhérazade" was not only a highly successful ballet based on Rimsky-Korsakov's tone poem, but also the name of a short-lived luxury magazine edited by Cocteau (first issue, 1909). Stravinsky, the most important composer attached to the Ballets Russes, was to set Cocteau's oratorio text "Oedipus Rex" in 1927.

50 Nijinsky, whose strenuous role in this ballet (music: Weber's "Invitation to the Dance") ended with an enormous leap, is shown resting. Among the onlookers, who can be identified from other drawings in this book, are Bakst, Diaghilev and the Serts (see following note).

53 J. M. S. was the Spanish painter José María Sert (1876–1945), who did designs for the Ballets Russes. His wife, the former Misia Edwards, was a musician and society woman.

60 This is Alexandre Millerand, President of France from 1920 to 1924.

65 The famous author of "Iceland Fisherman" (1850–1923).

80 The split was an important element of the Belle Epoque dance known as "le French cancan." "Le Grand Ecart" was also the title of Cocteau's first novel, published, as this book was, in 1923.

90 Cocteau's adaptation of Sophocles' "Antigone" was first performed in 1921.

91 The story of Oedipus was of great interest to Cocteau, who was to make use of it in several of his later writings.

96 A reference to Nietzsche's well-known book "Menschliches, Allzumenschliches."

103 "Rimes riches" in French prosody are rhymes in which the vowel sound and (at least) the consonant sound following the vowel sound are the same in both rhyme words: e.g. "pour" and "tour."

106 A French girl, Suzanne Lenglen, was the world's leading woman tennis player between 1919 and 1926.

108 Louis Antoine Léon de Saint-Just (1767–1794), an associate of Robespierre during the Reign of Terror.

109 Morand (born 1889), a French diplomat and writer of popular novels.

115 The dome in this expression is that of the Institut de France; thus, the man depicted is a member of the Académie Française.

117 M. de Charlus is a Proustian character; the episode of the false duel occurs in "Cities of the Plain."

124 Thermidor was the month from mid-July to mid-August in the French revolutionary calendar; the downfall of Robespierre occurred in Thermidor, An II (July 1794).

126 A stage version of Verne's novel was one of Cocteau's most beloved childhood memories. In 1936 Cocteau actually made just such a trip, which he described in a book called "Mon premier Voyage" (My First Journey).

THE ILLUSTRATIONS

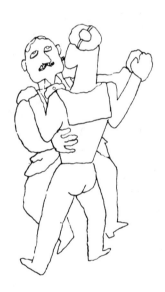

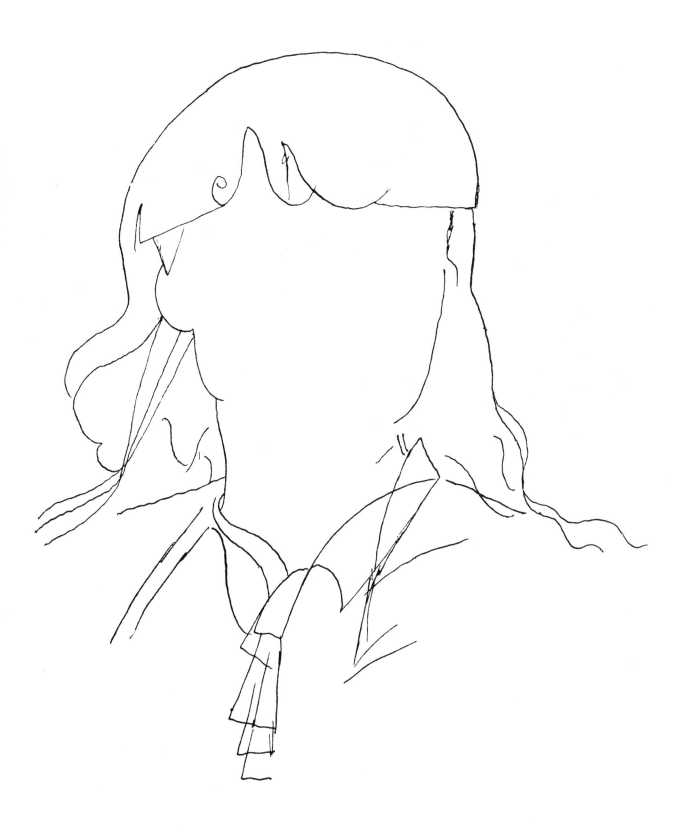

The Countess de Noailles: Silhouette I
Comtesse de Noailles: Silhouette

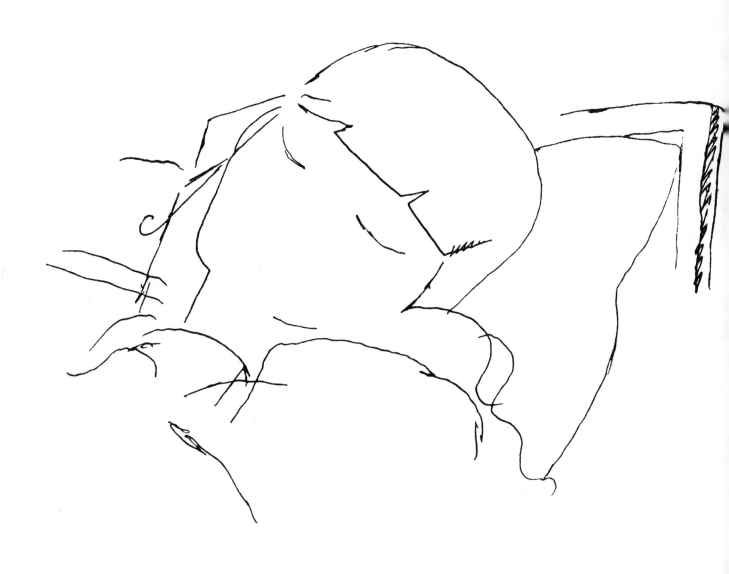

2 The Countess de Noailles: Silhouette

Comtesse de Noailles: Silhouette

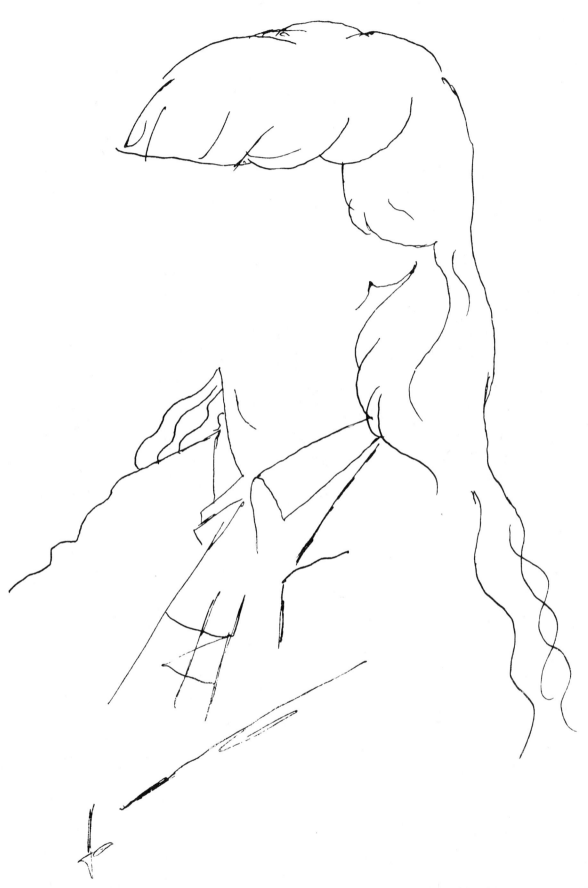

The Countess de Noailles: Silhouette **3**

Comtesse de Noailles: Silhouette

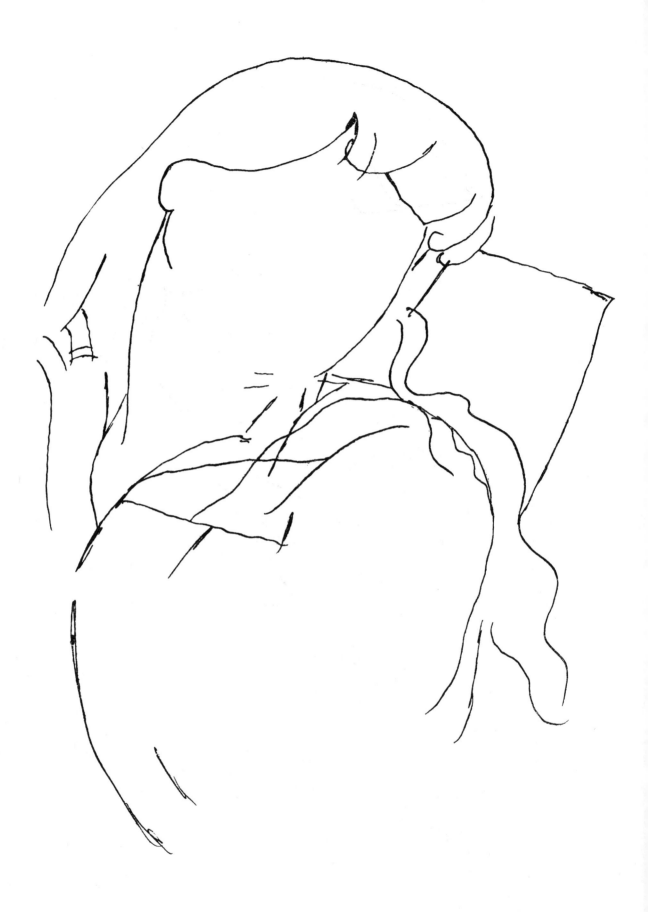

4 The Countess de Noailles: Silhouette
Comtesse de Noailles: Silhouette

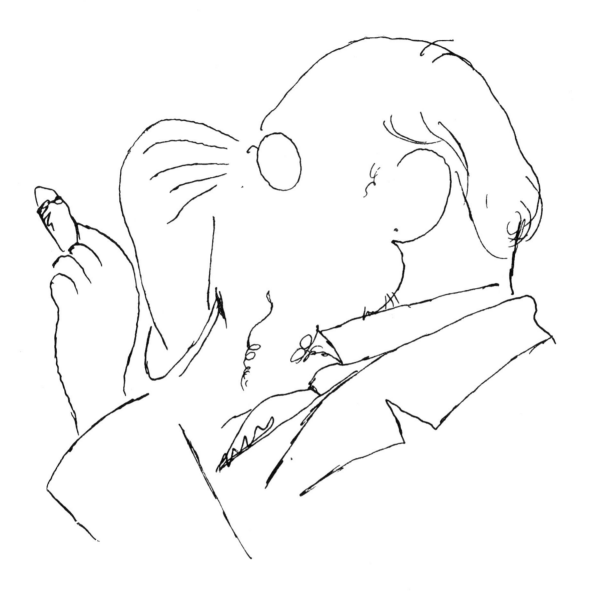

Erik Satie 5

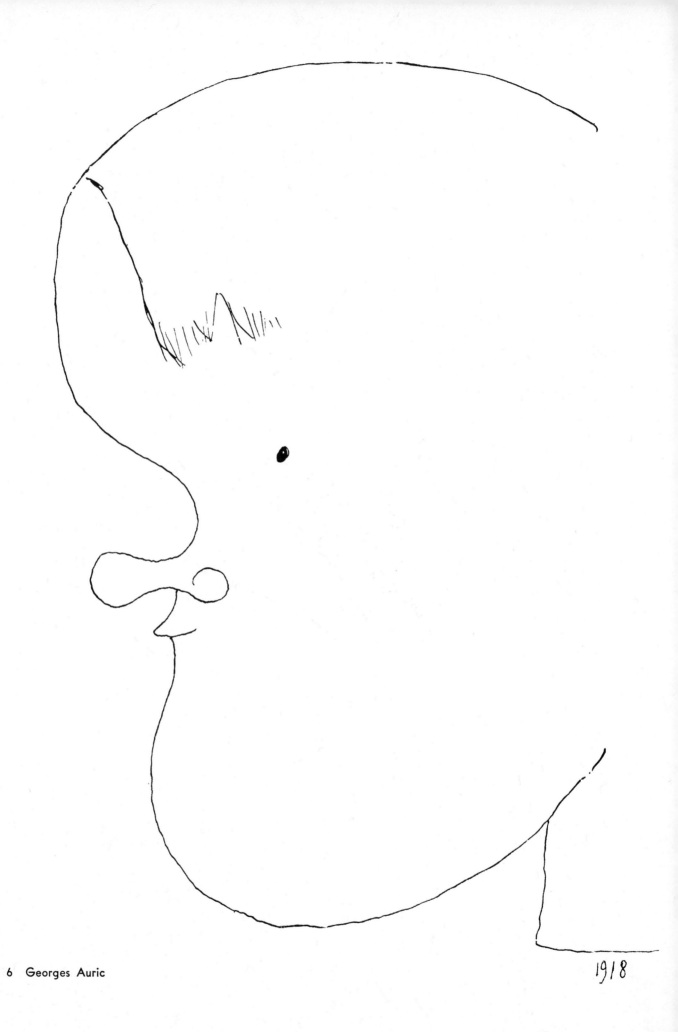

6 Georges Auric

1918

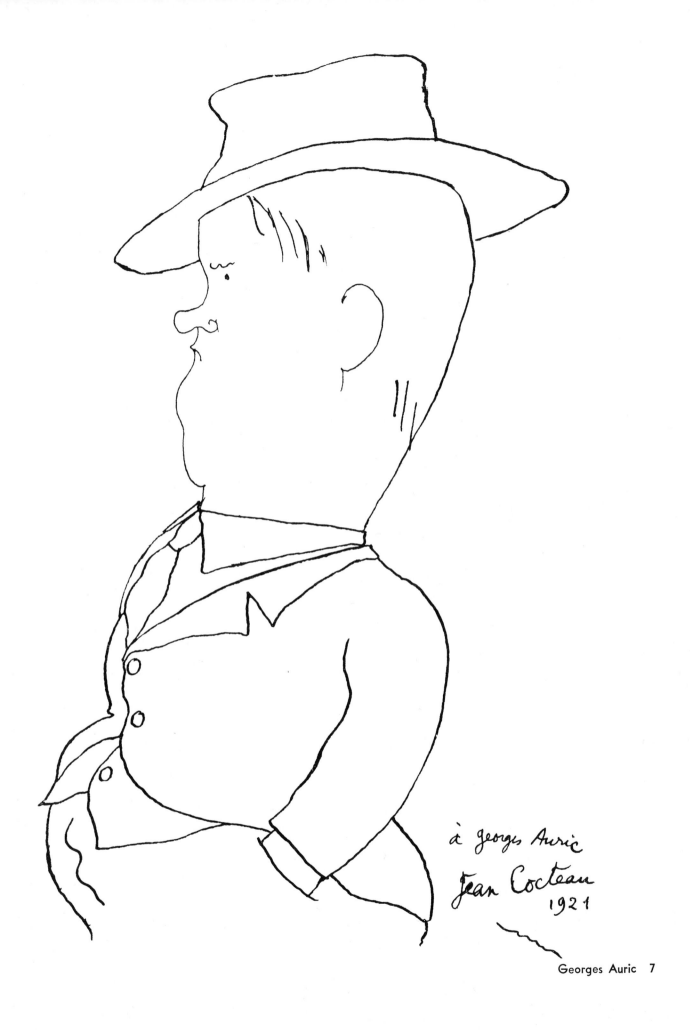

à Georges Auric

Jean Cocteau

1921

Georges Auric 7

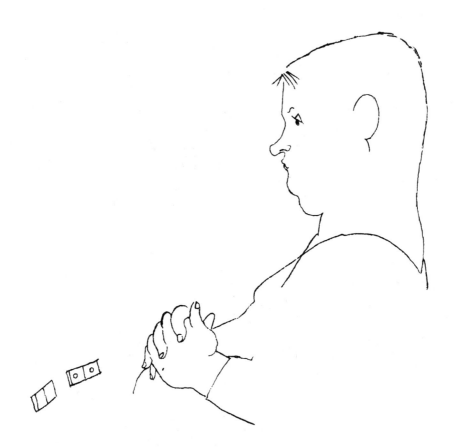

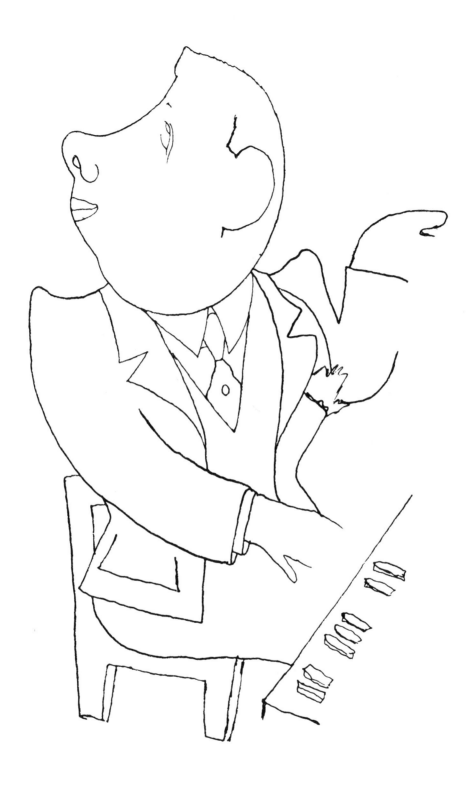

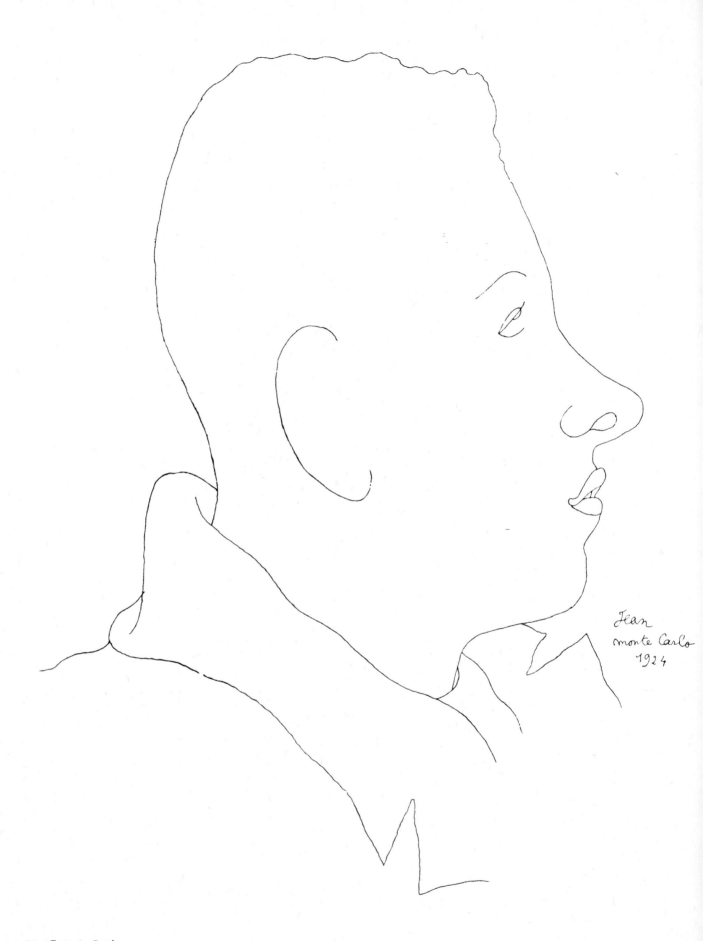

Jean
monte Carlo
1924

10 Francis Poulenc

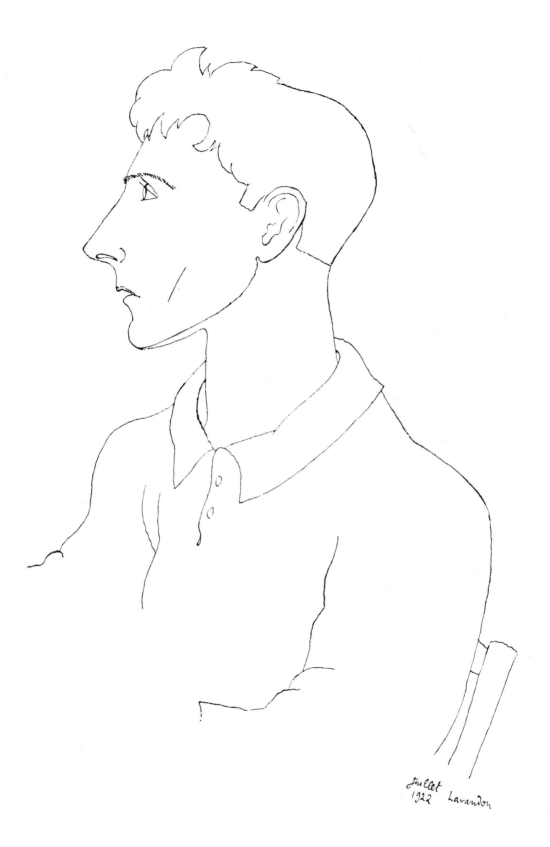

Juillet 1922 Lavandou

The traveler on the ice (or, through mirrors) [self-portrait] 11
Le Voyageur dans les glaces

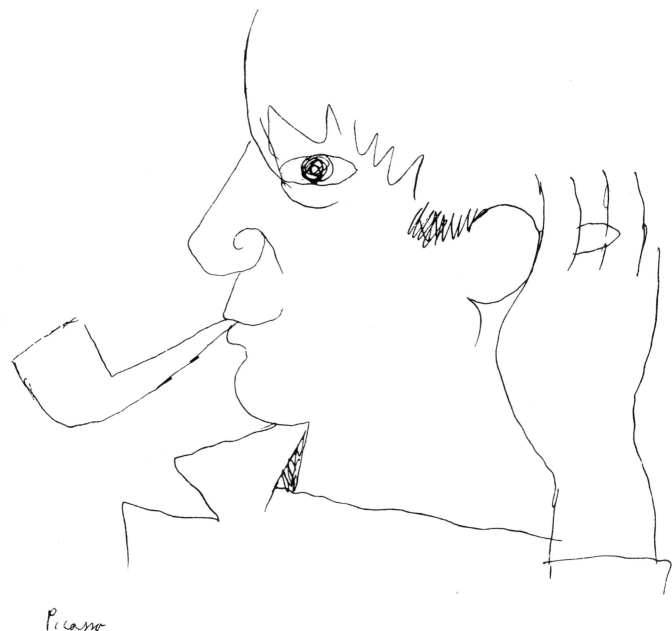

Picasso
a Rome
1917

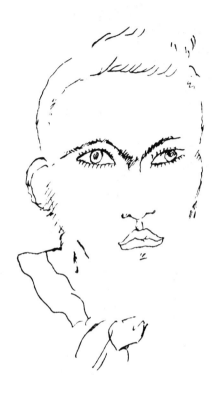

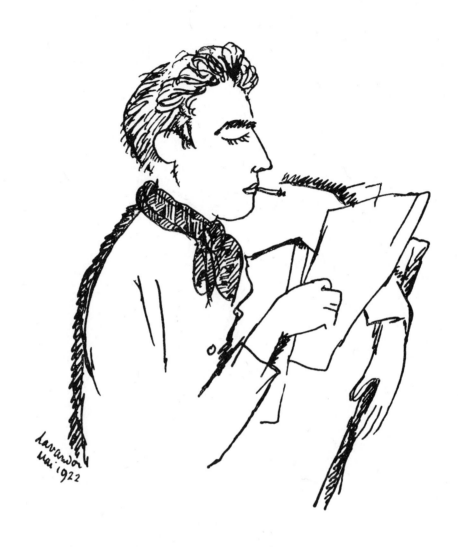

14 Raymond Radiguet

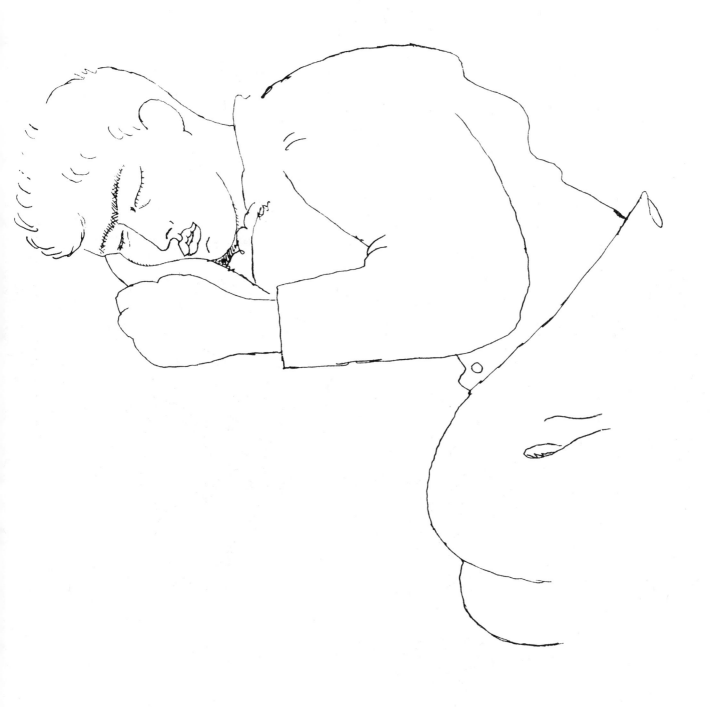

Raymond Radiguet: The poet sleeping 15
Le Poète endormi

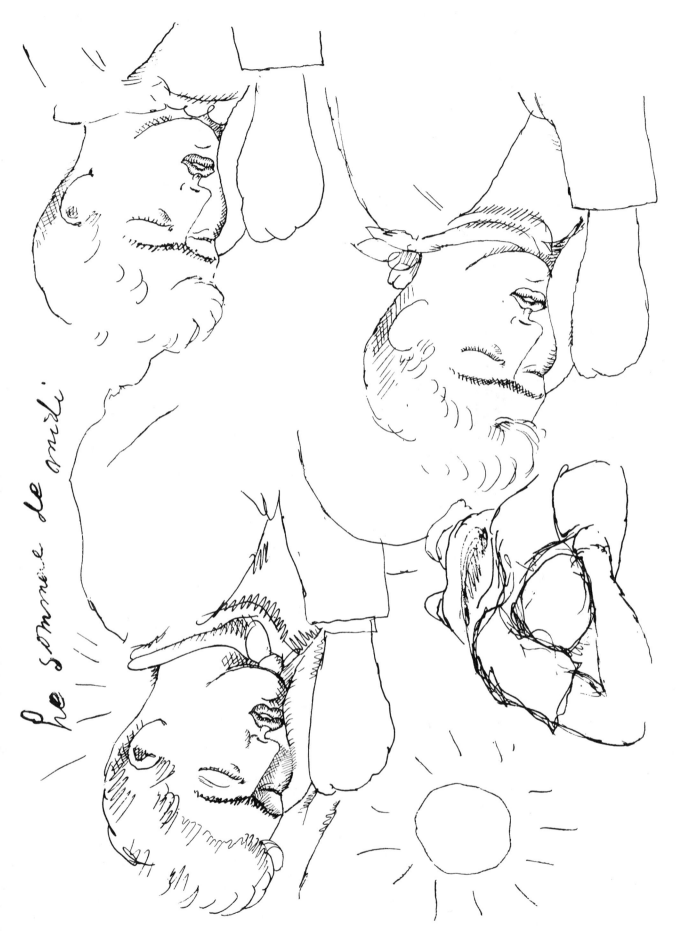

Le sommeil de midi.

Raymond Radiguet: The noonday nap
Le Sommeil de midi

16

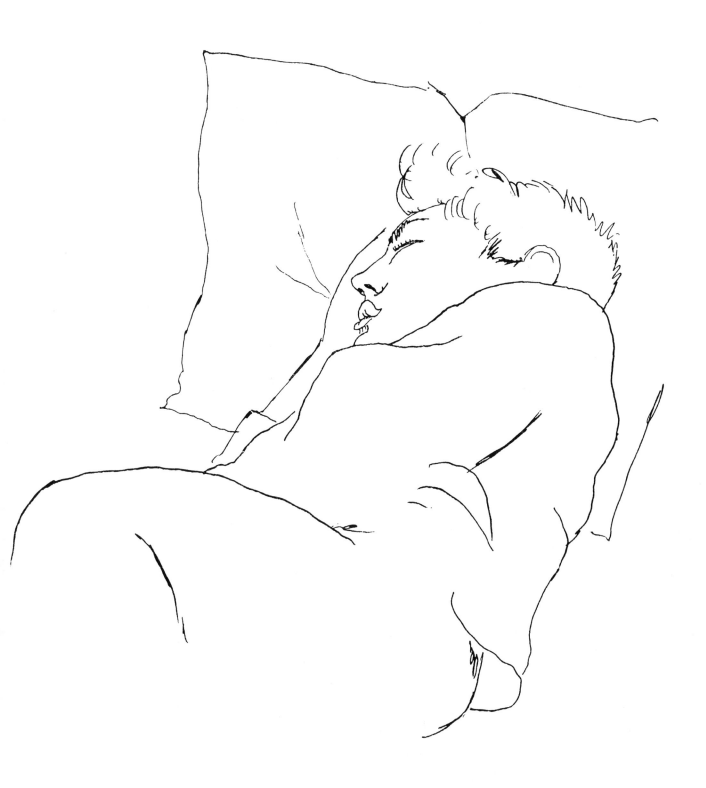

Raymond Radiguet 17

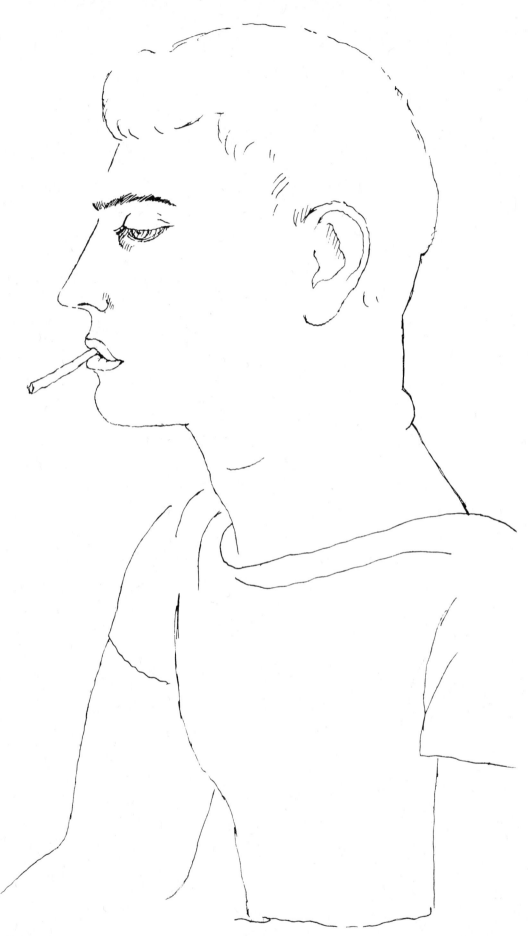

18 Raymond Radiguet

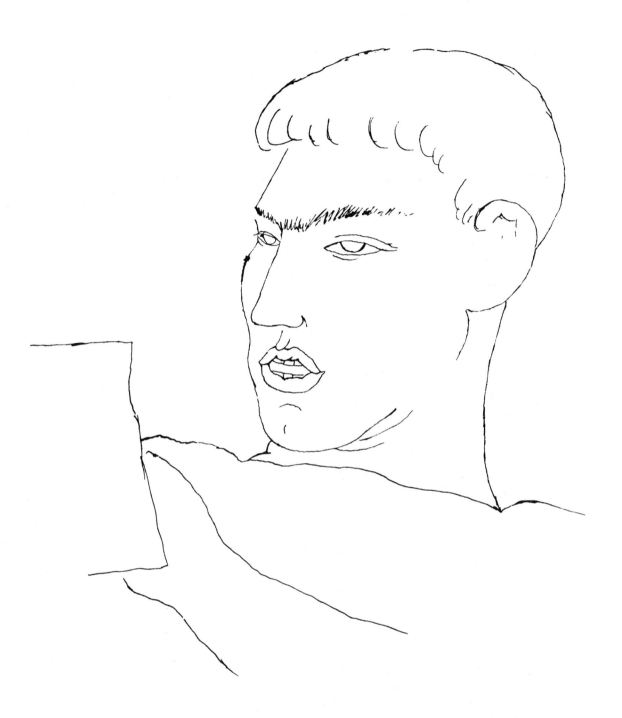

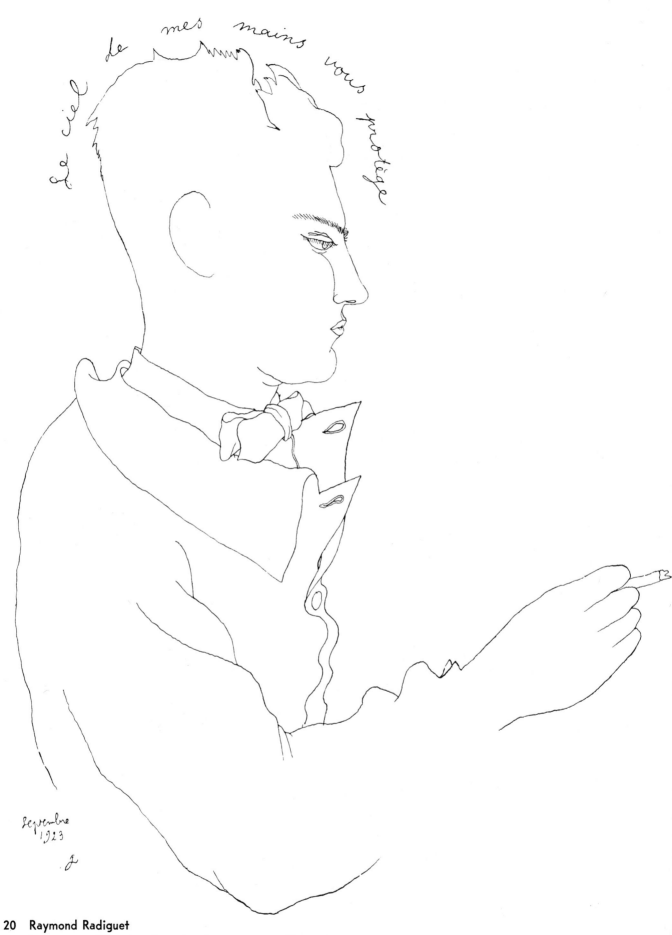

20 Raymond Radiguet

[Inscription: "The sky of my hands protects you."]

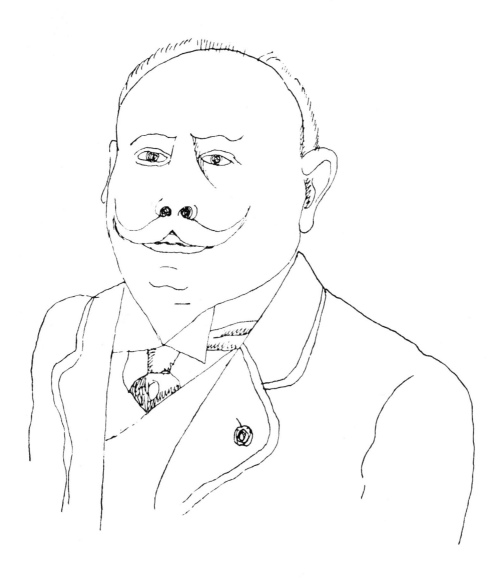

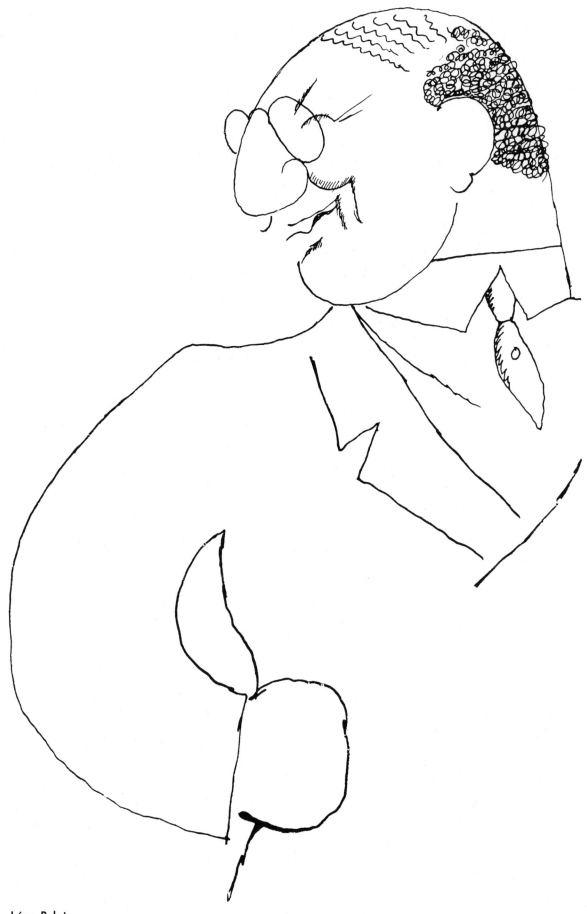

22 Léon Bakst

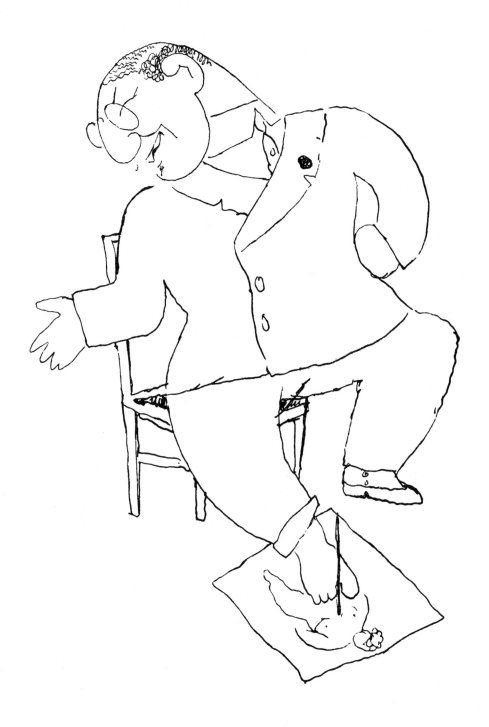

Léon Bakst 23

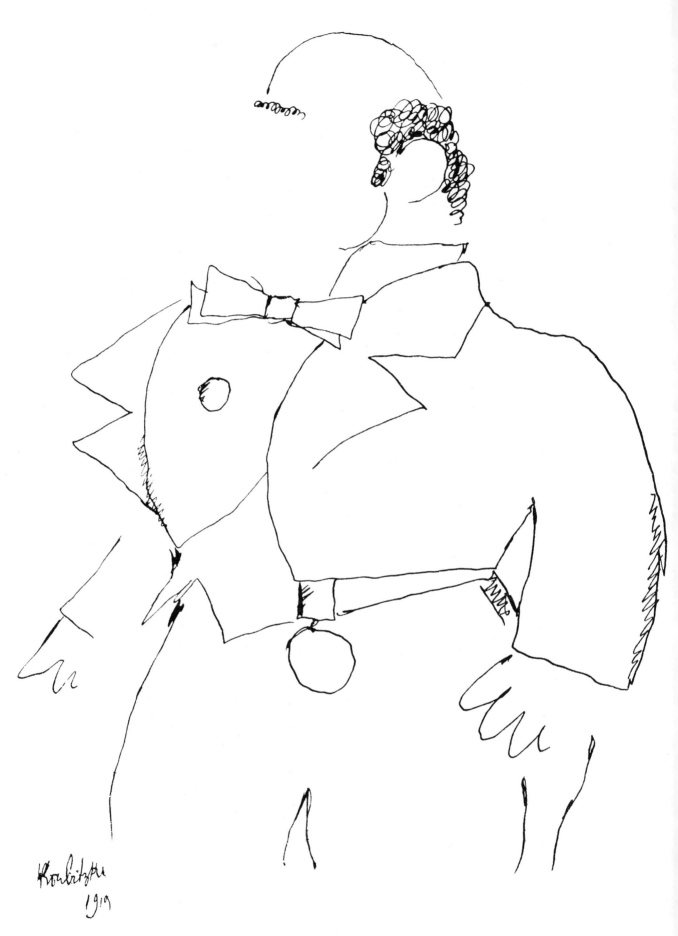

24 Koubitzky

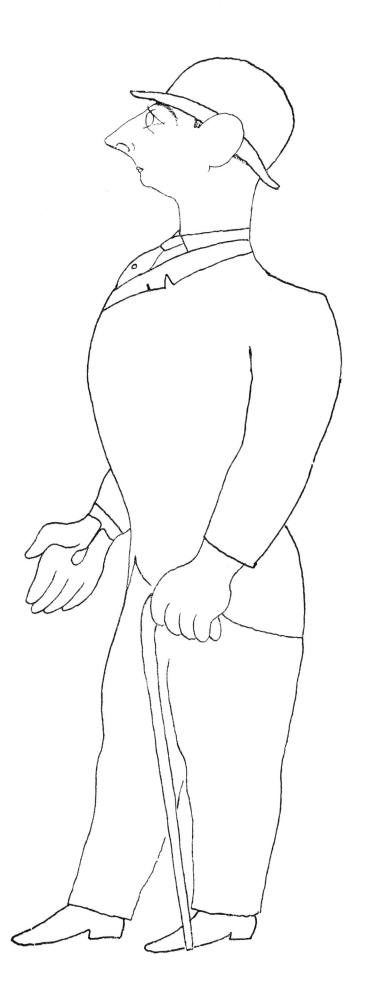

Jean V. Hugo 25

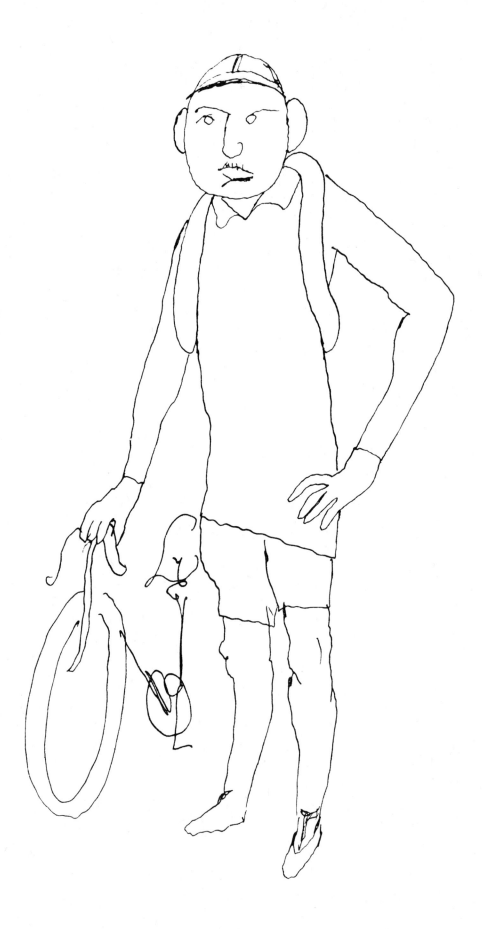

26 The bridge at Chatou
Le Pont de Chatou

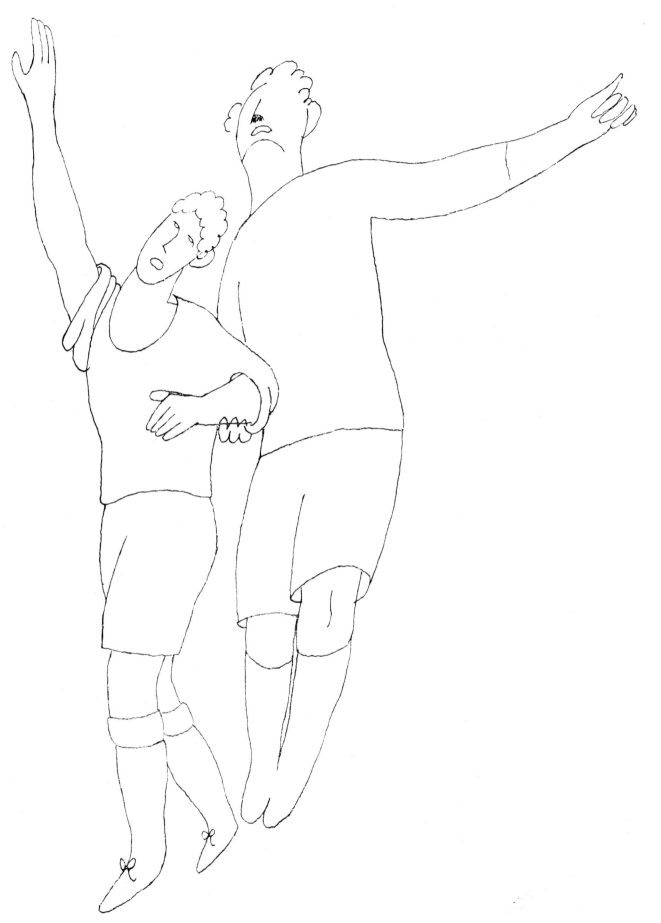

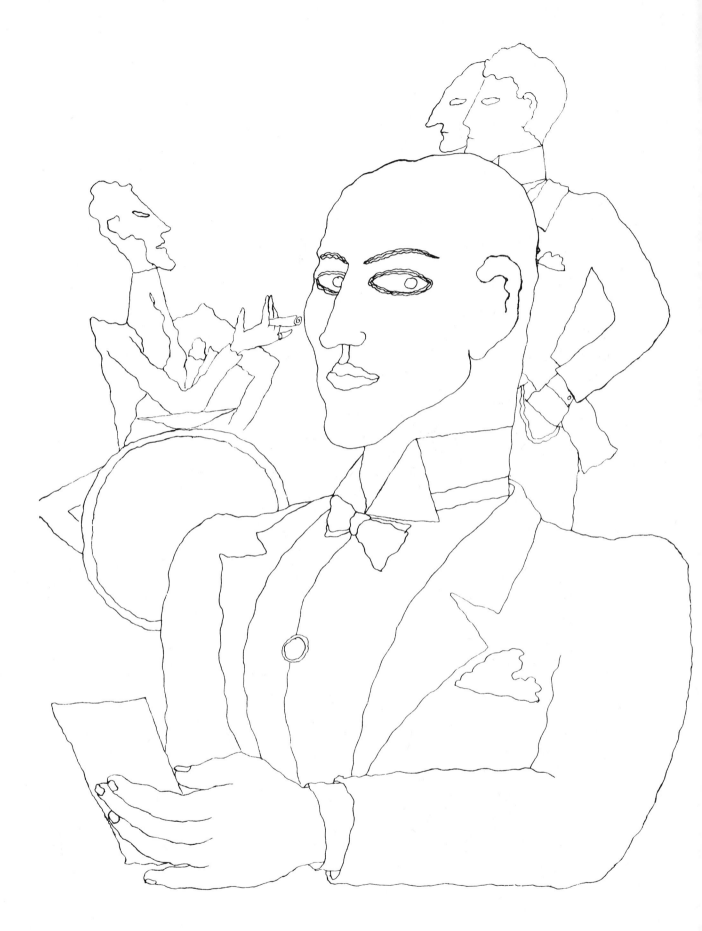

28 The den of iniquity
Le mauvais Lieu

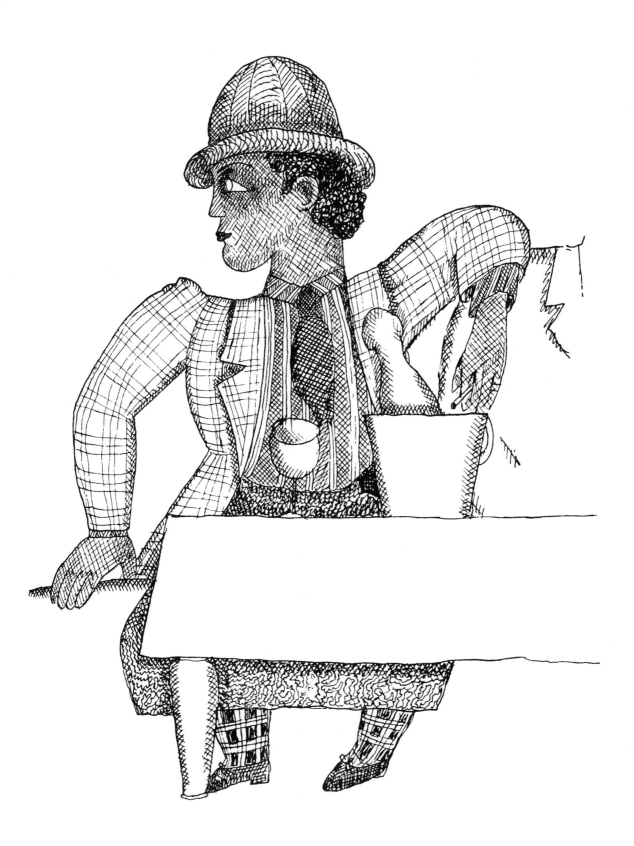

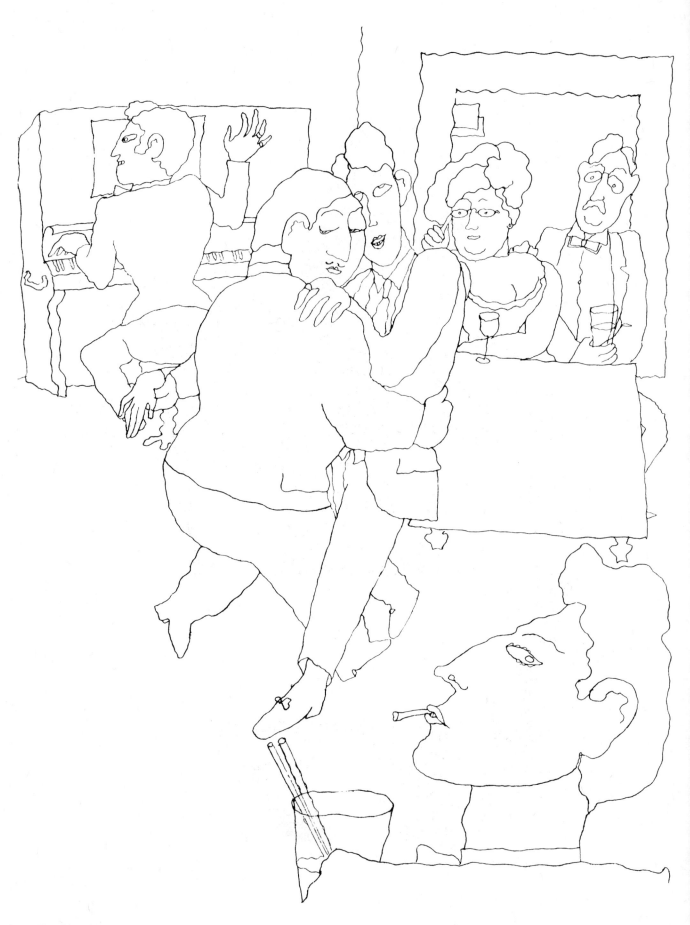

30 The den of iniquity
Le mauvais Lieu

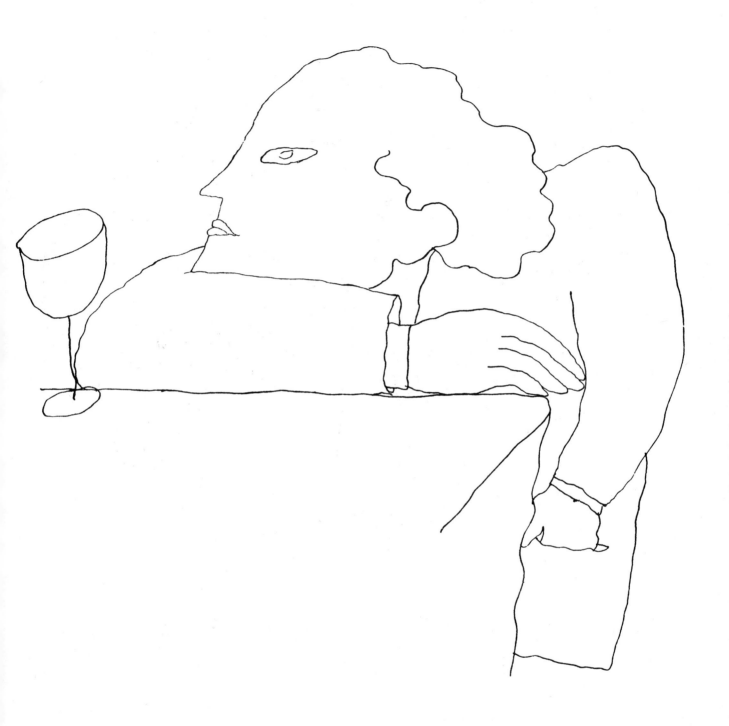

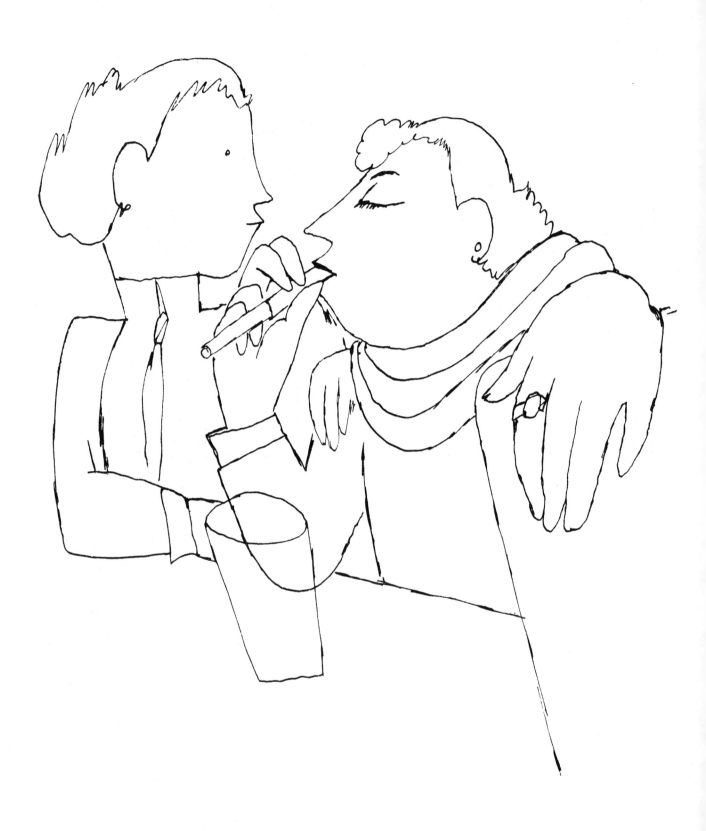

32 The den of iniquity
Le mauvais Lieu

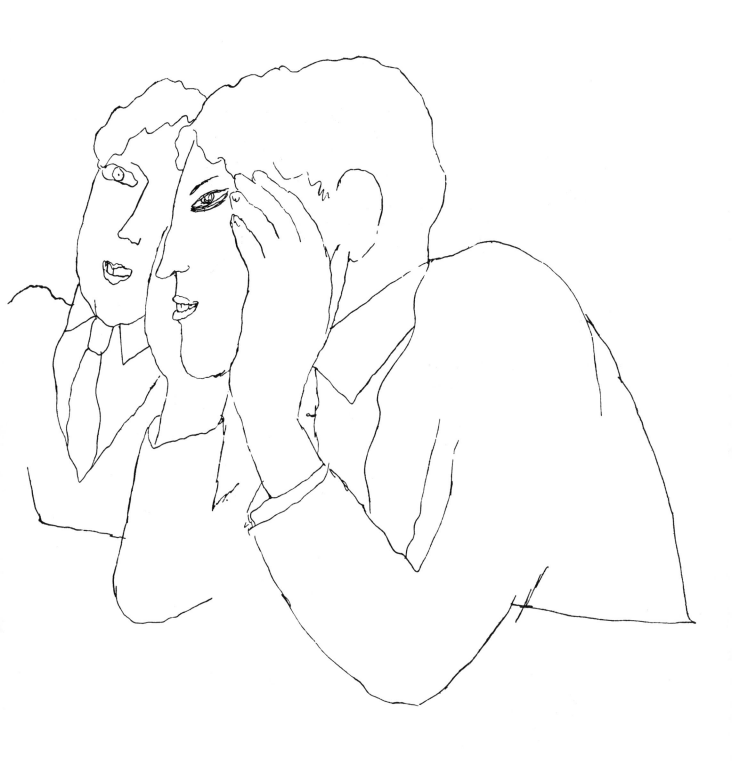

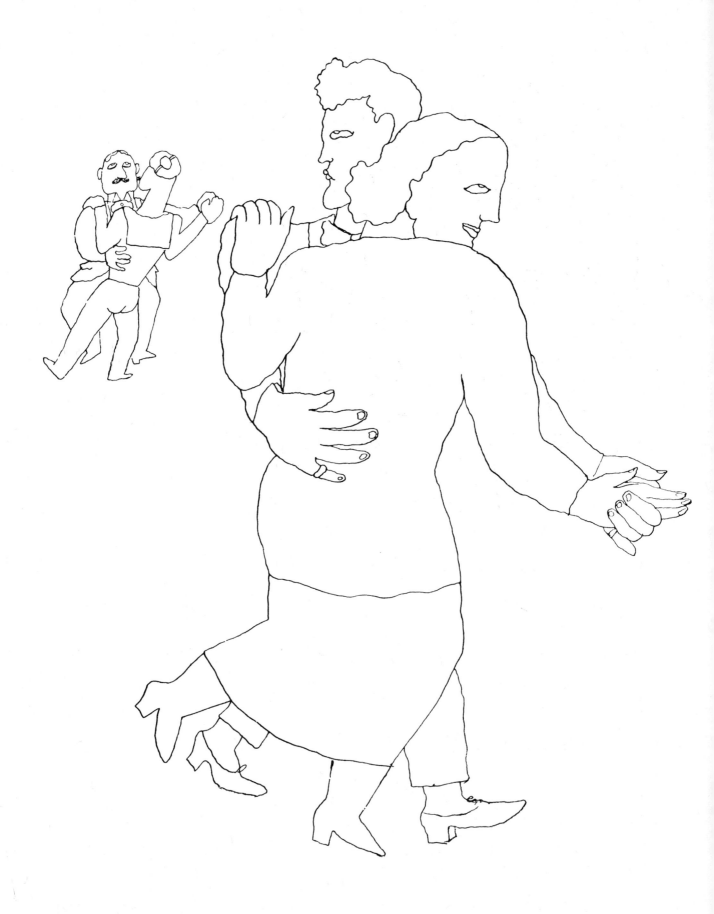

34 The den of iniquity
Le mauvais Lieu

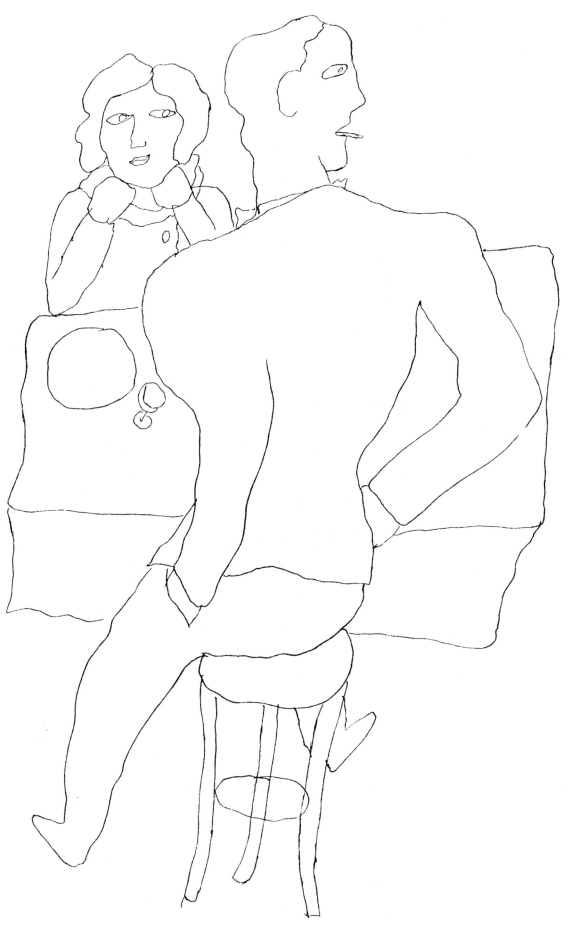

The den of iniquity 35
Le mauvais Lieu

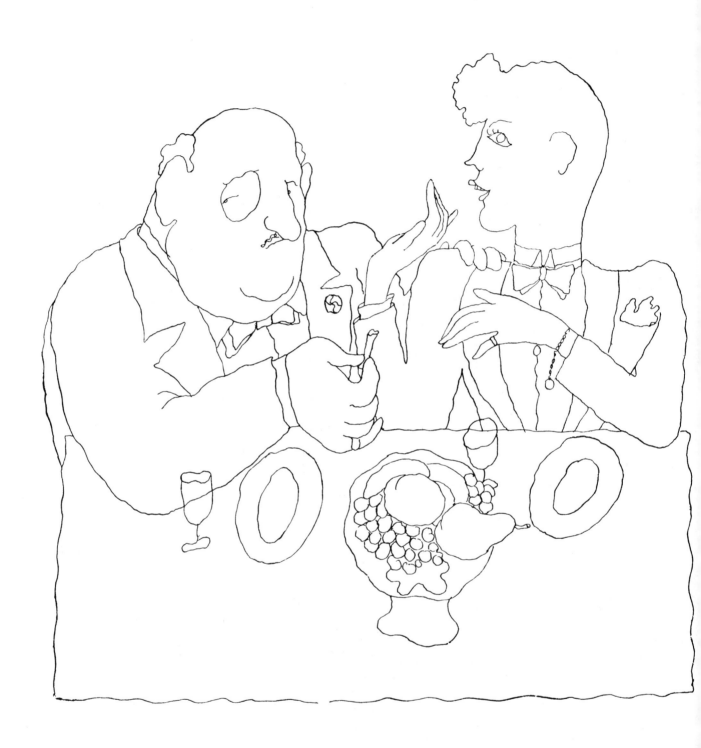

36 **The den of iniquity**
Le mauvais Lieu

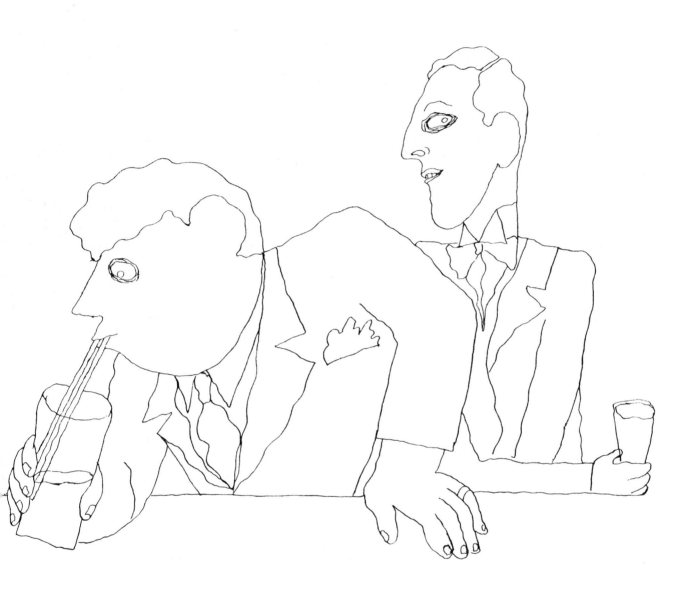

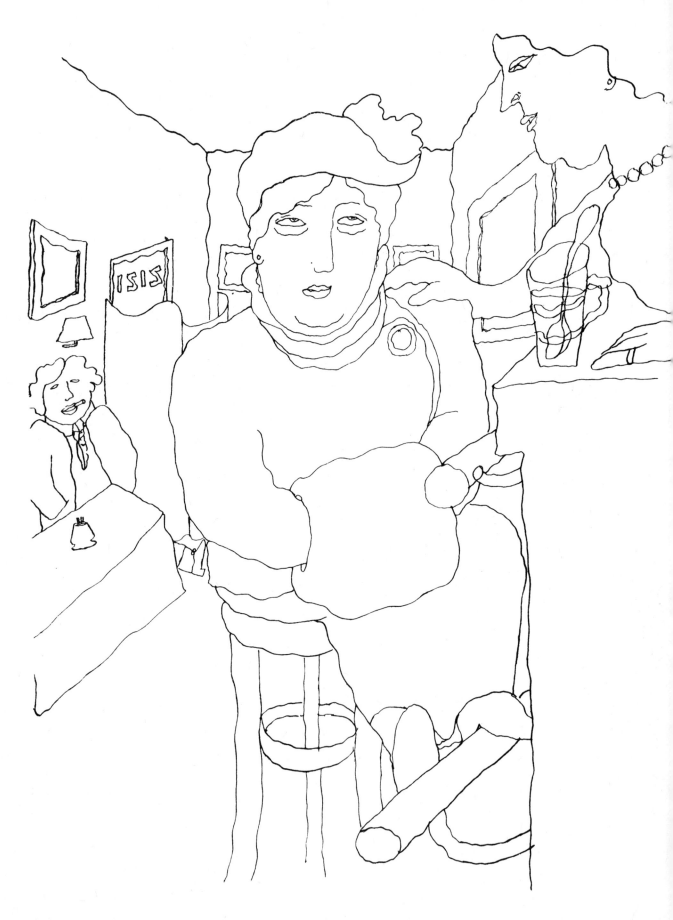

38 The den of iniquity
Le mauvais Lieu

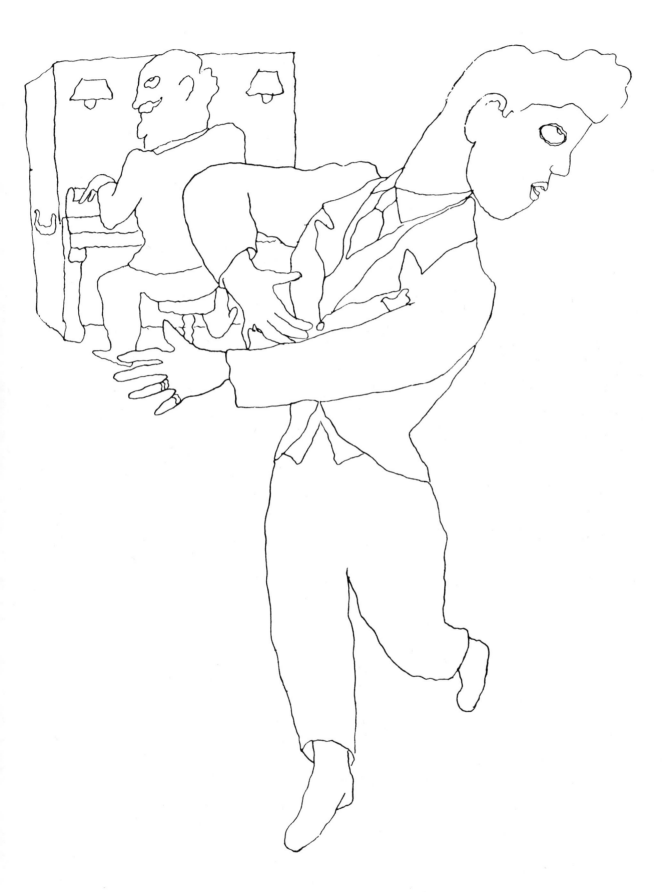

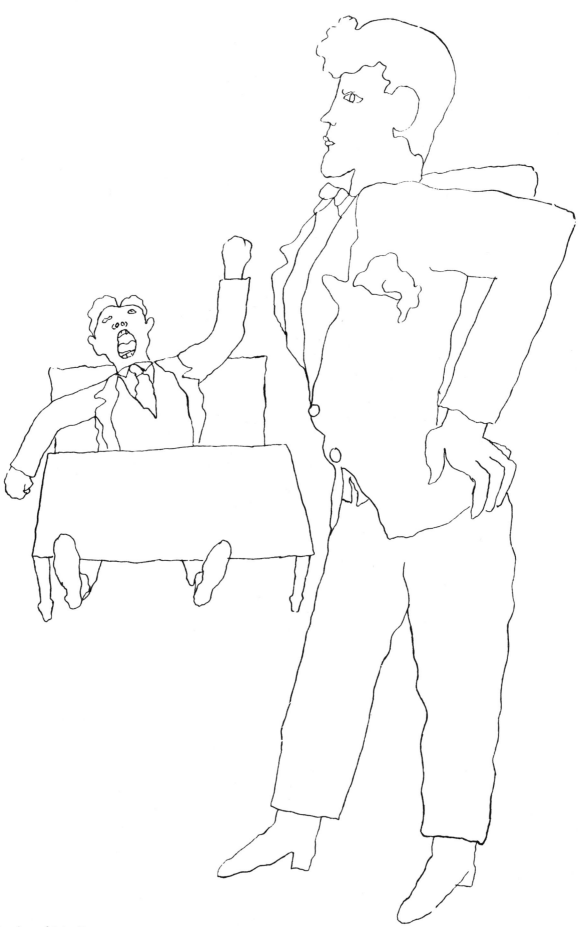

40 The den of iniquity
Le mauvais Lieu

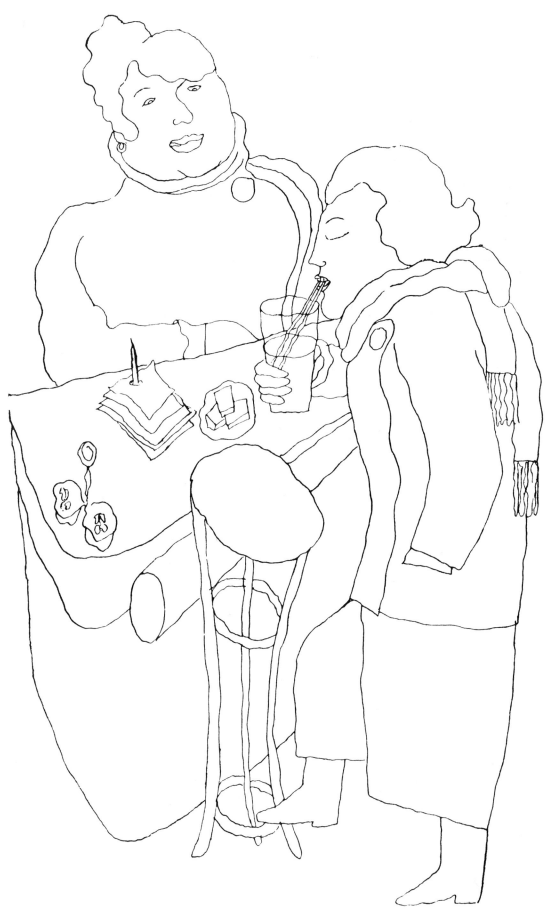

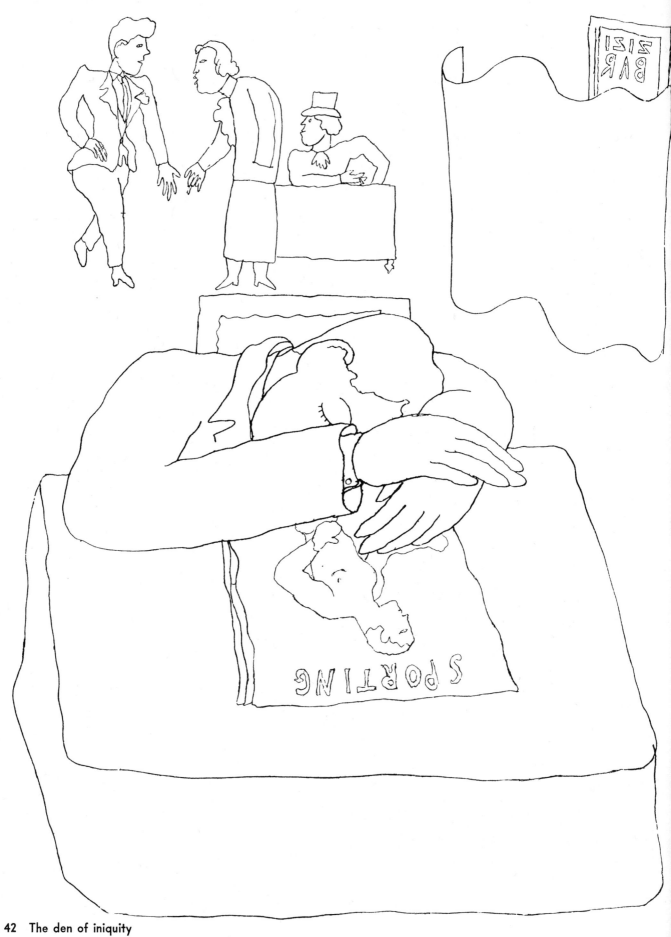

42 The den of iniquity
Le mauvais Lieu

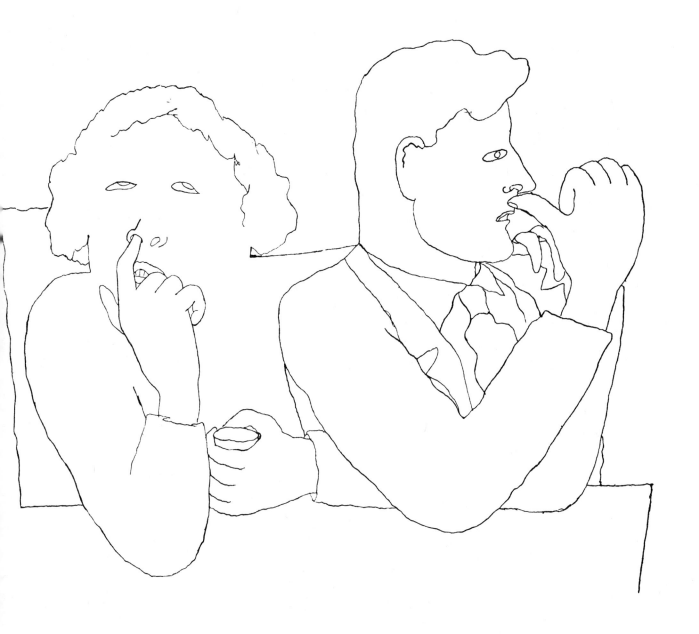

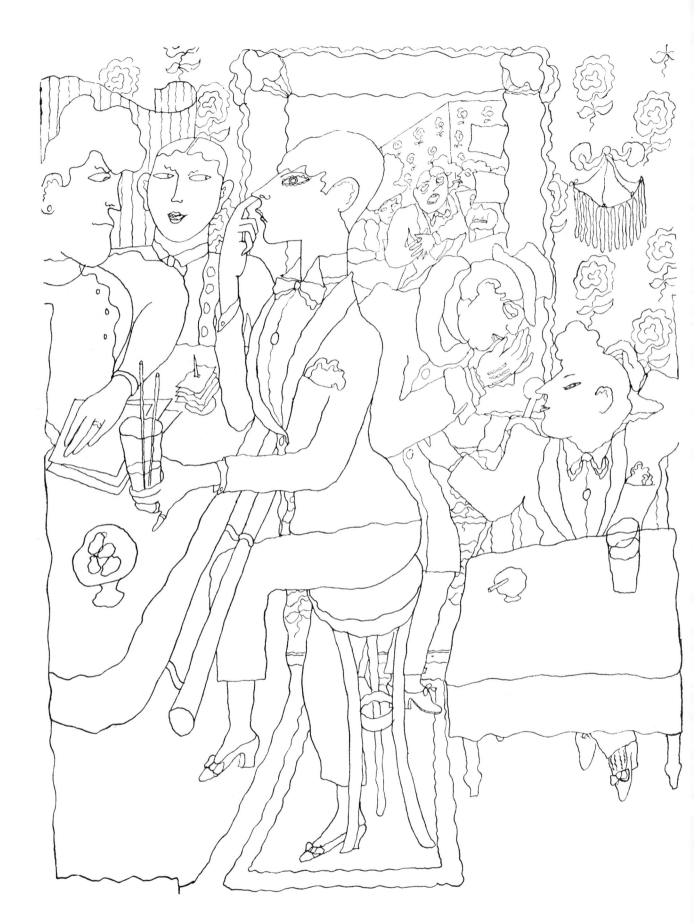

44 The den of iniquity
Le mauvais Lieu

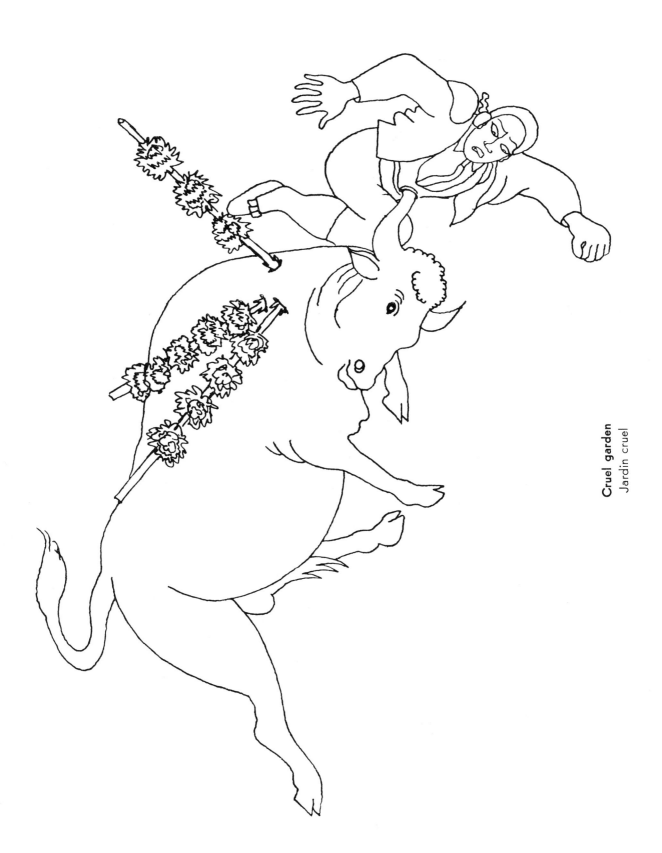

Cruel garden
Jardin cruel

45

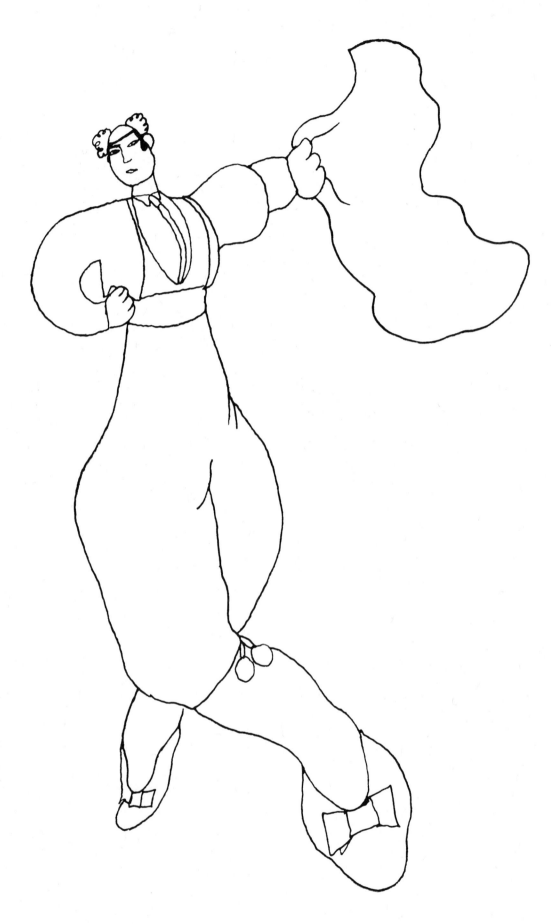

46 Frogs and bulls are caught by means of red objects
Les Grenouilles et les taureaux se prennent avec du rouge

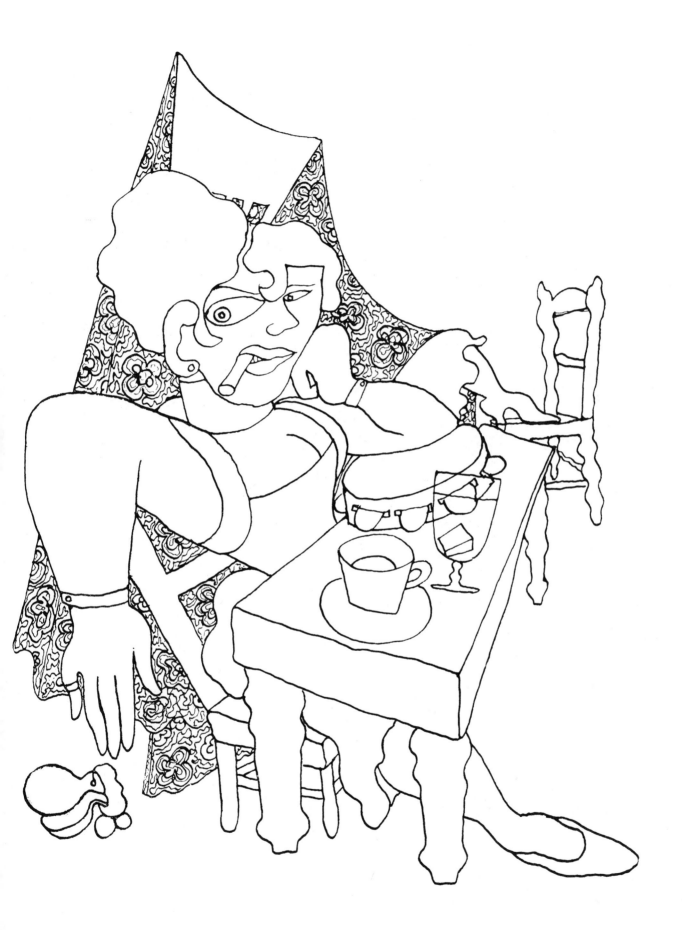

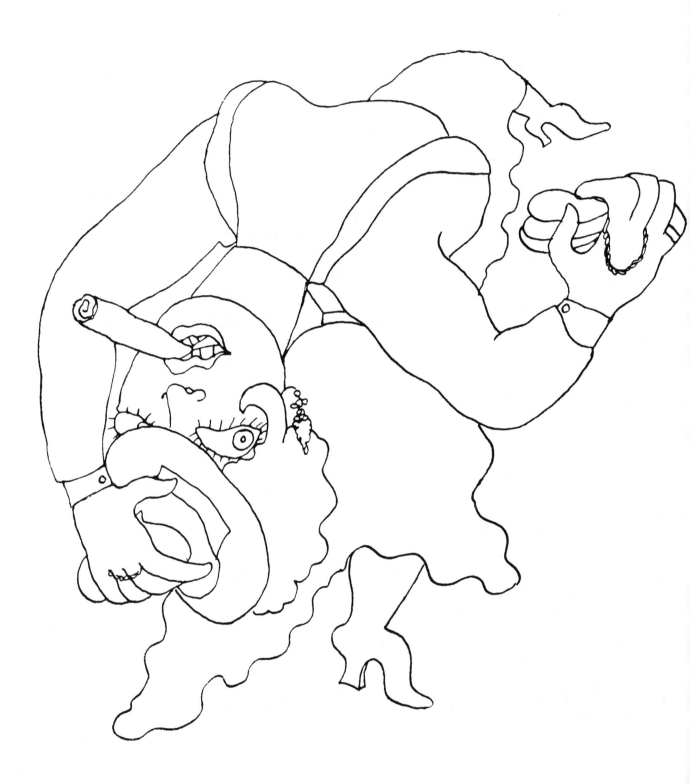

48 Chabrier

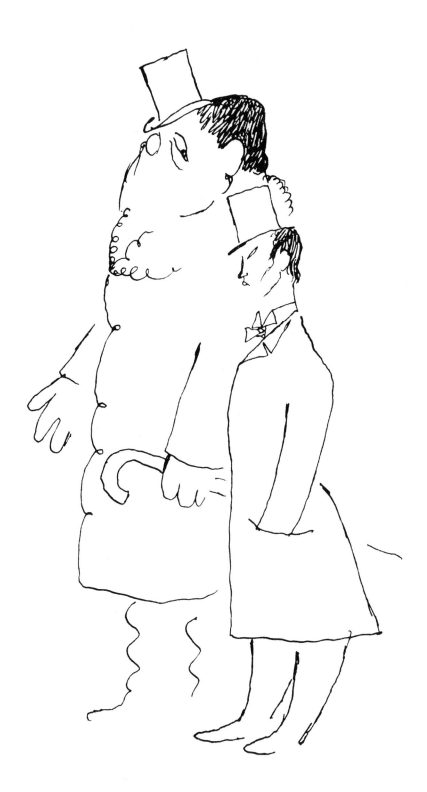

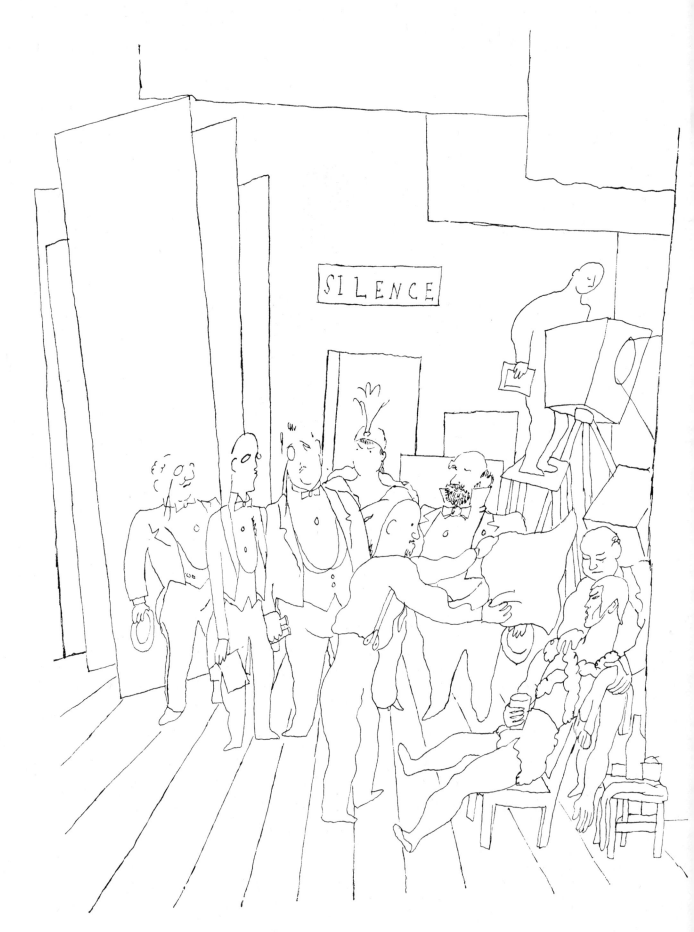

50 **Memories of the Ballets Russes: Backstage after "The Spectre of the Rose"**
Souvenirs du Ballet Russe: Les Coulisses à la fin du "Spectre de la Rose"

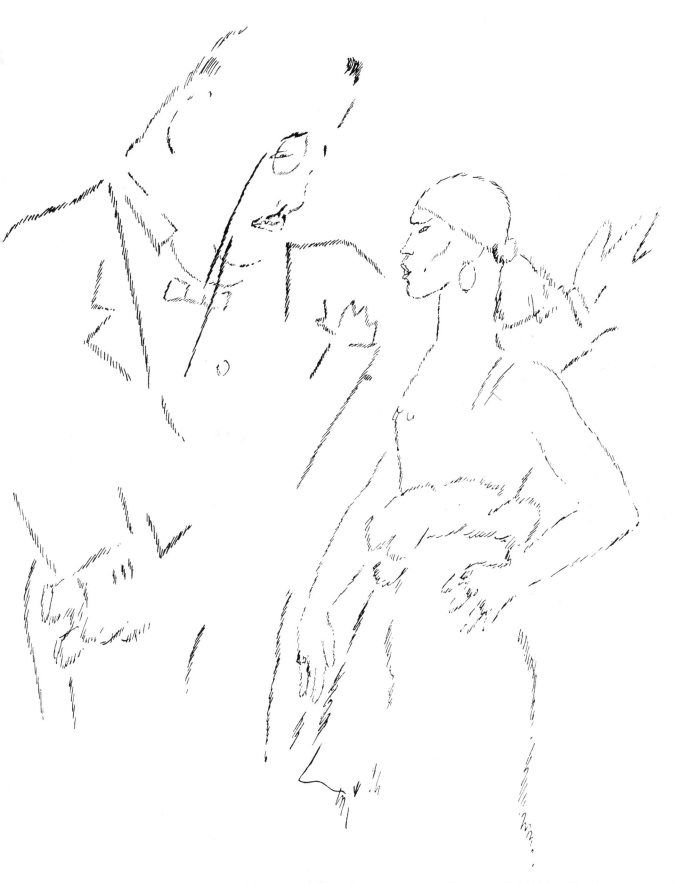

Memories of the Ballets Russes: Serge Diaghilev/V. Nijinsky ("Schéhérazade") 51
Souvenirs du Ballet Russe: Serge de Diaghilew/W. Nijinsky (Shéhérazade)

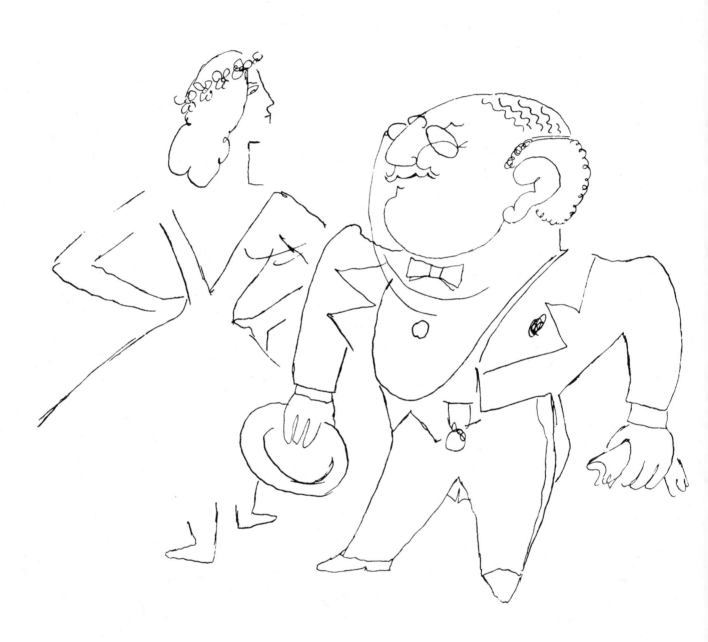

52 Memories of the Ballets Russes: Léon Bakst
Souvenirs du Ballet Russe: Léon Bakst

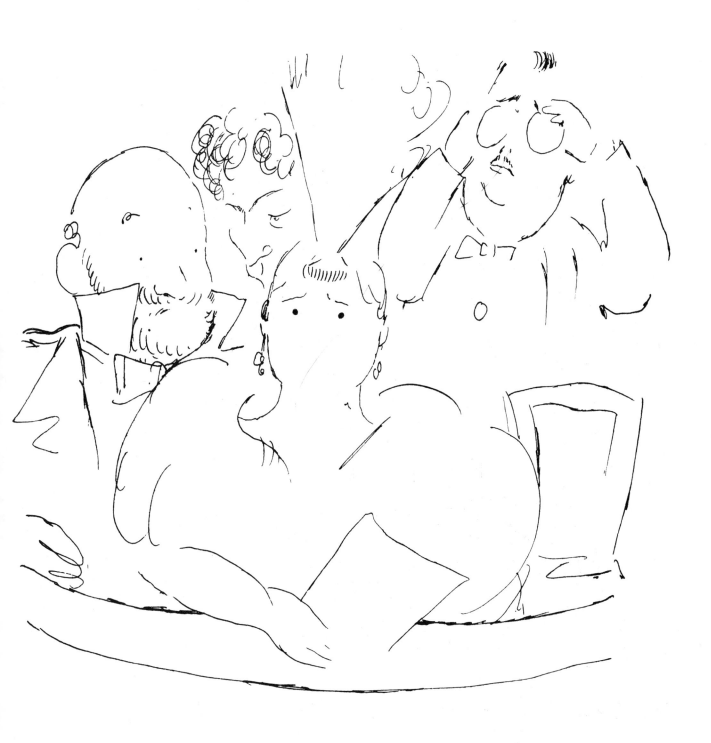

Memories of the Ballets Russes: Mr. and Mrs. J. M. S./Serge Diaghilev 53
Souvenirs du Ballet Russe: Monsieur et Madame J. M. S./Serge de Diaghilew

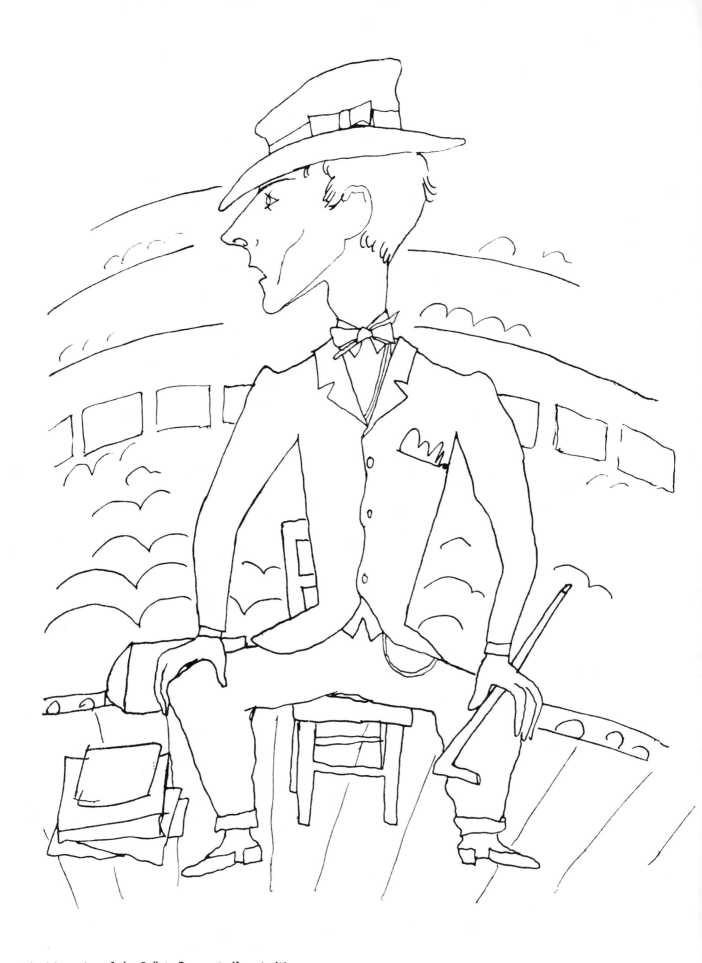

54 Memories of the Ballets Russes [self-portrait]
Souvenirs du Ballet Russe

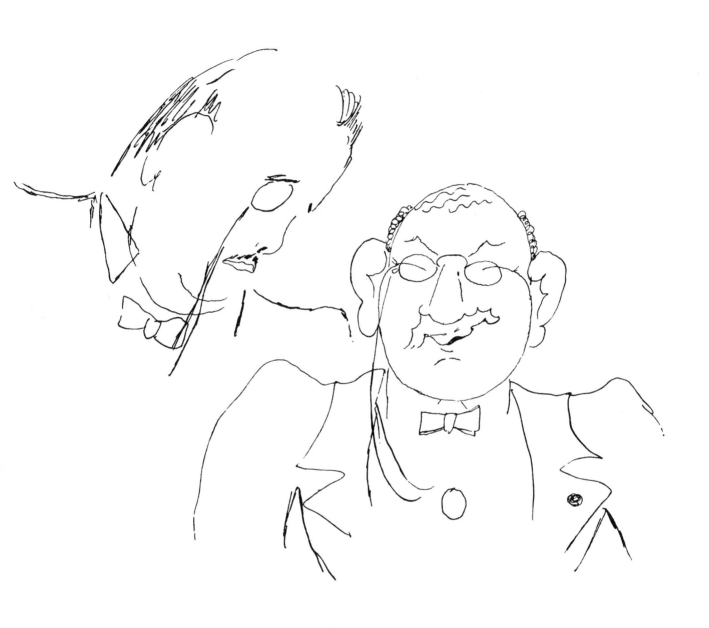

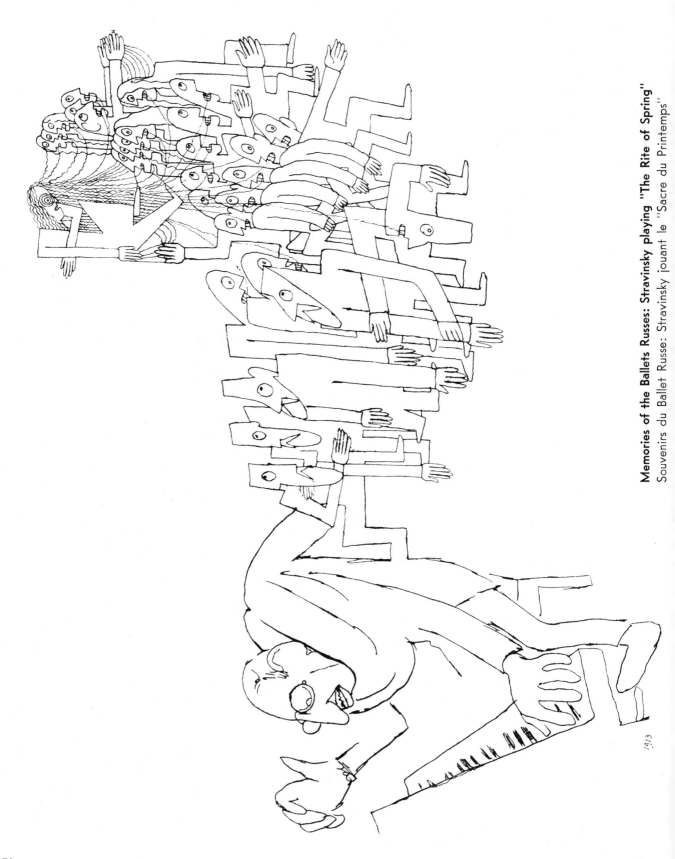

Memories of the Ballets Russes: Stravinsky playing "The Rite of Spring"
Souvenirs du Ballet Russe: Stravinsky jouant le "Sacre du Printemps"

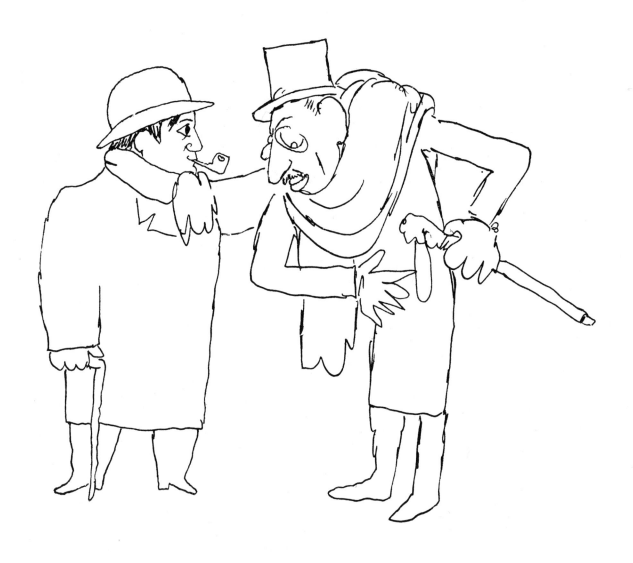

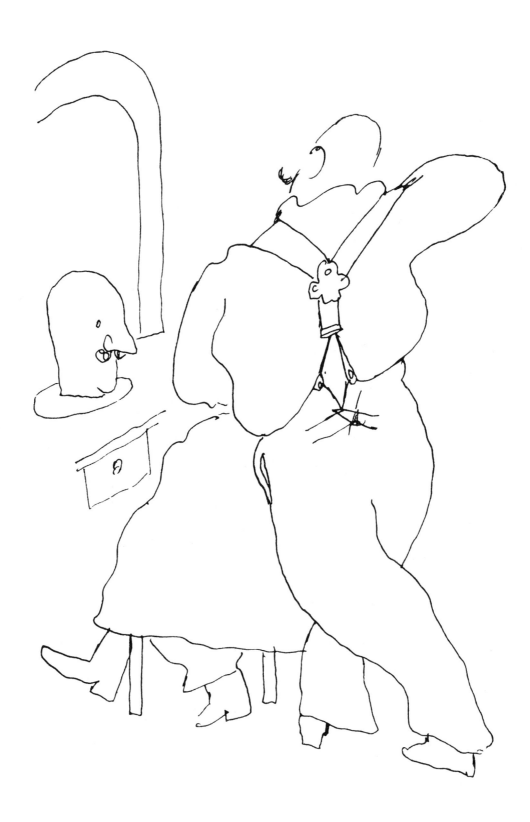

58 Memories of Toulon: The Toulon barber
Souvenirs de Toulon: Le Coiffeur de Toulon

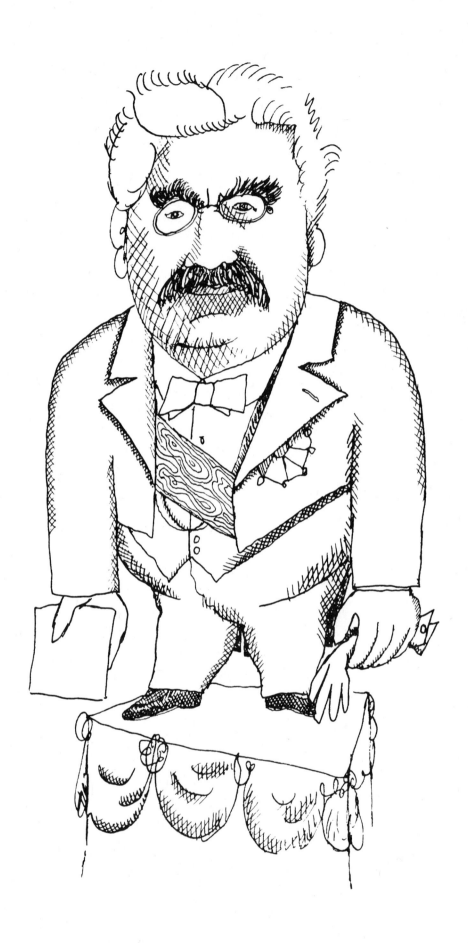

60 Memories of Toulon: The President of the Republic
Souvenirs de Toulon: Le Président de la République

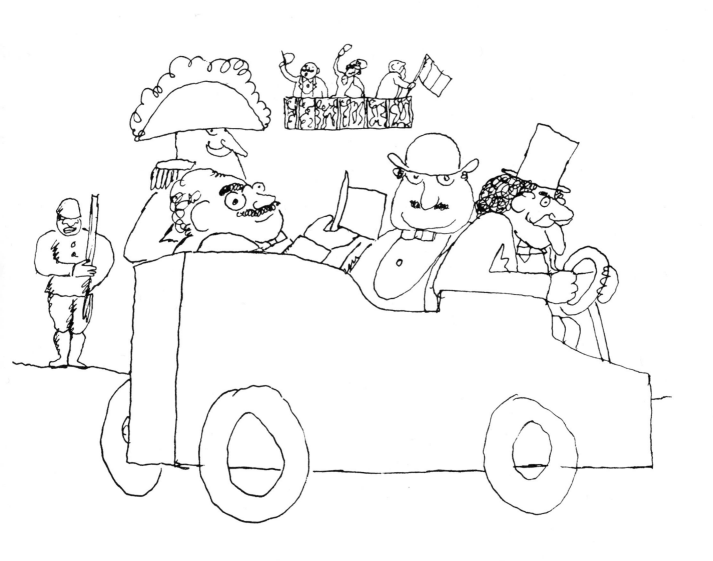

Souvenirs de Toulon: M. Millerand quitte Toulon

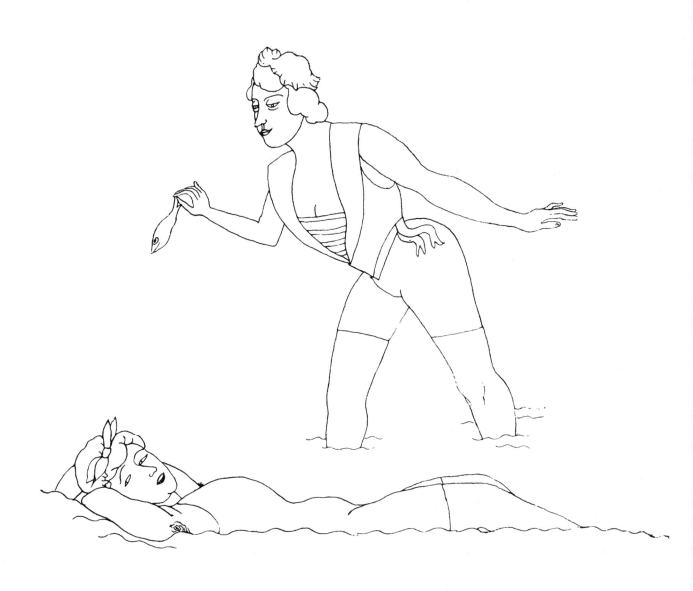

62 Memories of Toulon: Women bathing
Souvenirs de Toulon: Baigneuses

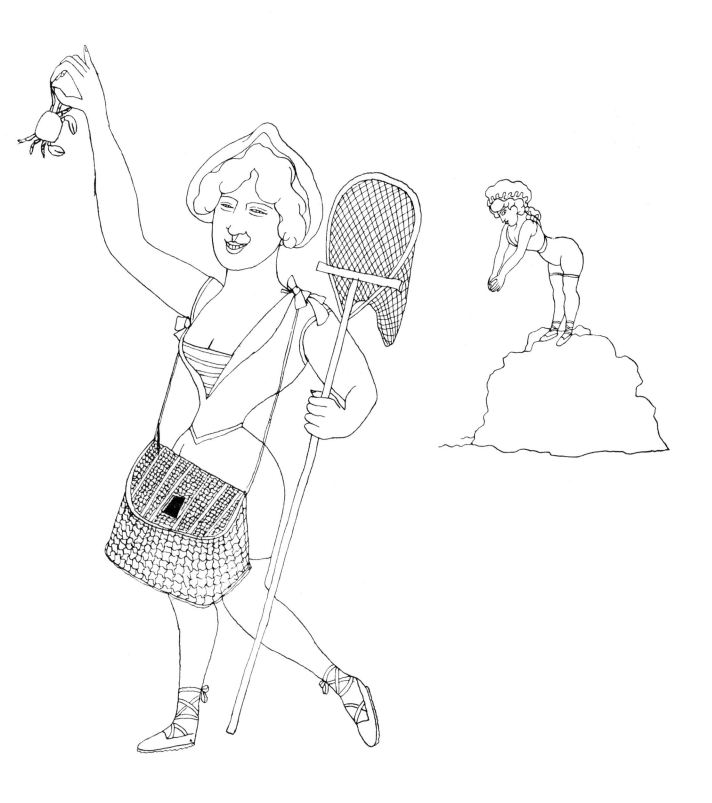

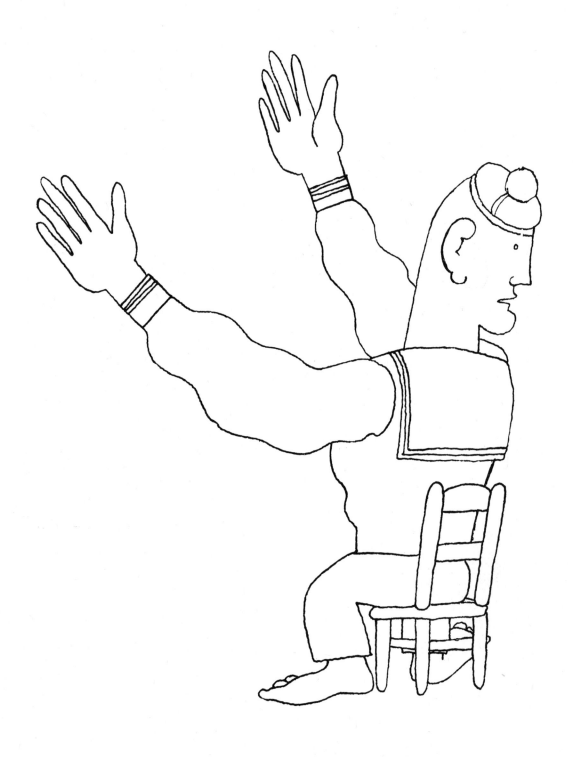

64 Memories of Toulon: Sailor telling tall stories
Souvenirs de Toulon: Marin racontant et mentant

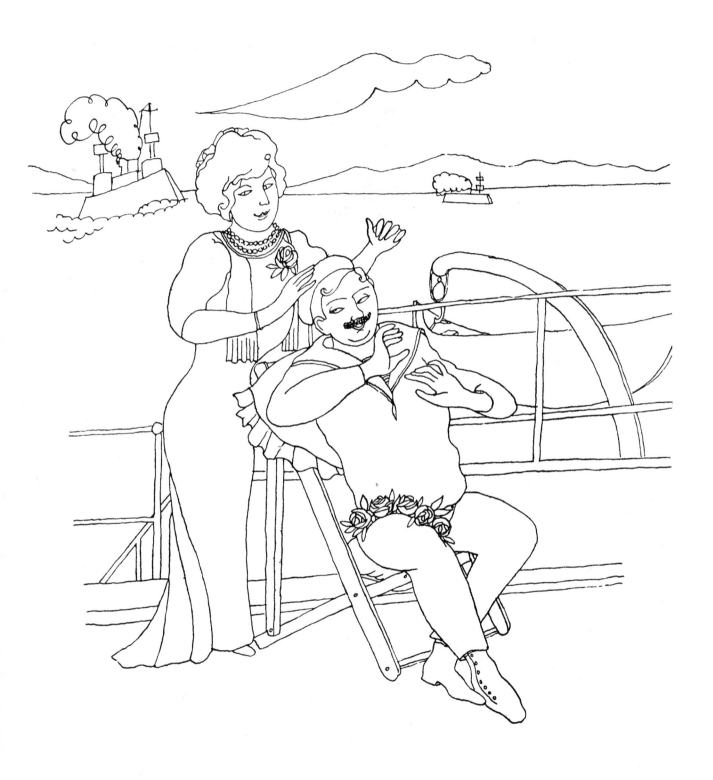

Souvenirs de Toulon: Pierre Loti

Memories of Toulon: The "Marseillaise"
Souvenirs de Toulon: La Marseillaise

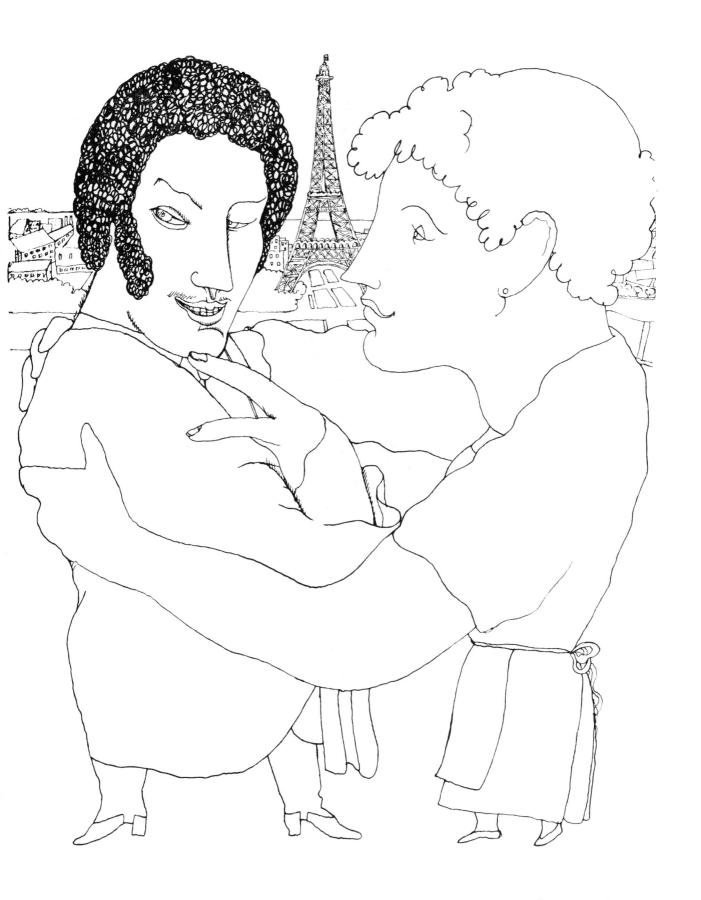

The poet and his muse 67
Le Poète et sa muse

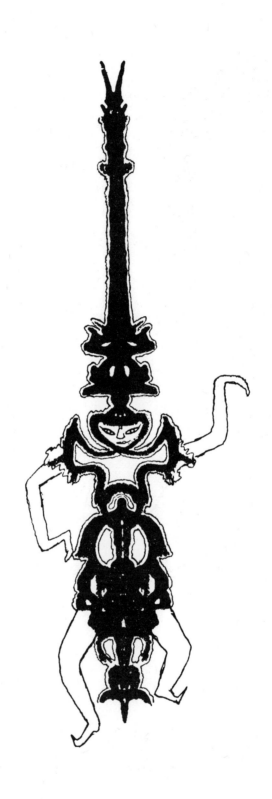

68 Lace walking
Dentelle en marche

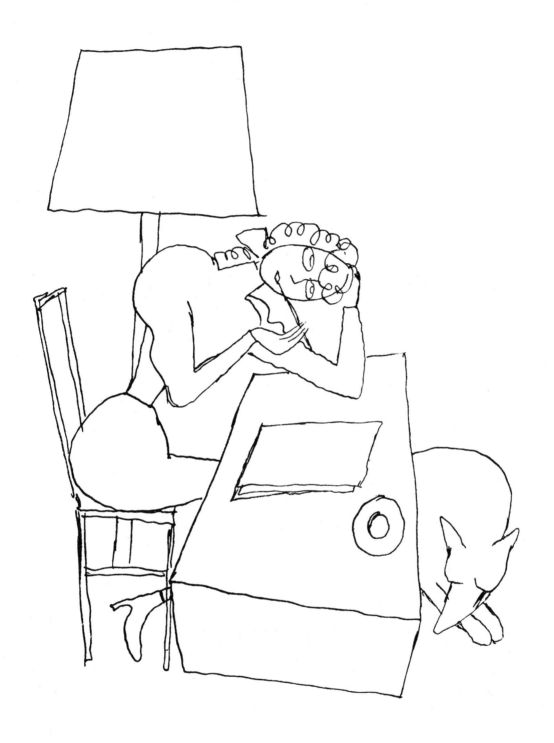

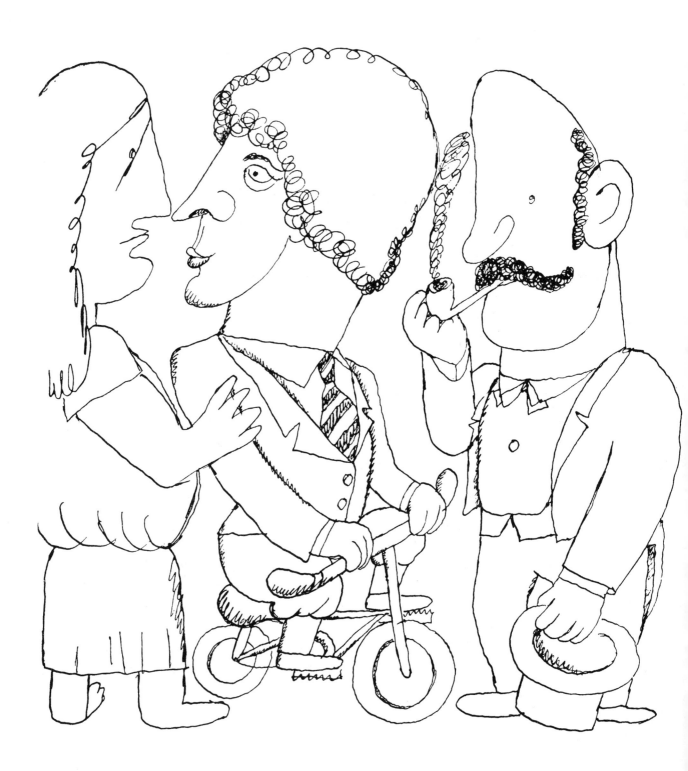

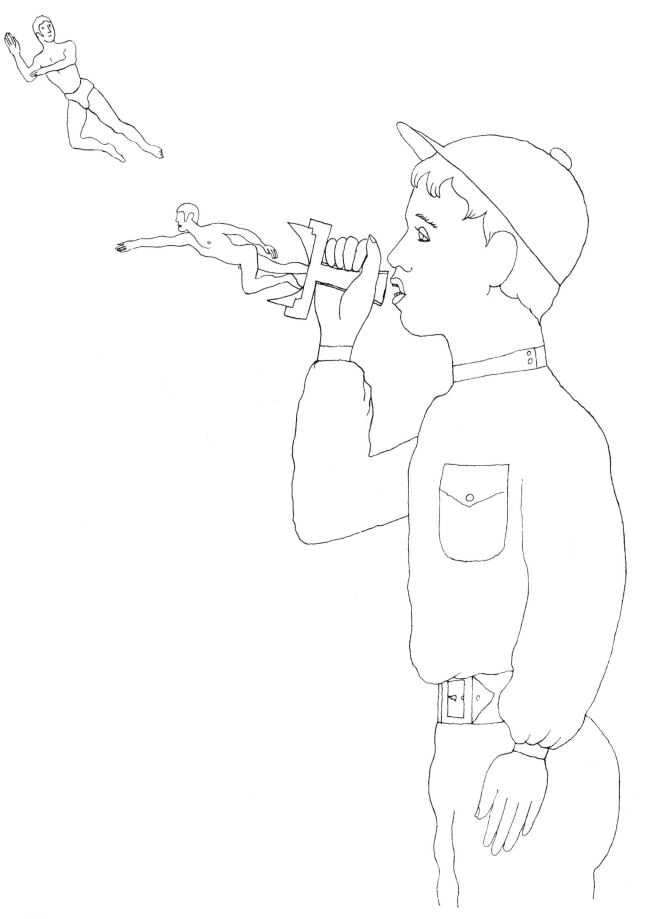

The delightful toy 71
Le Jouet délicieux

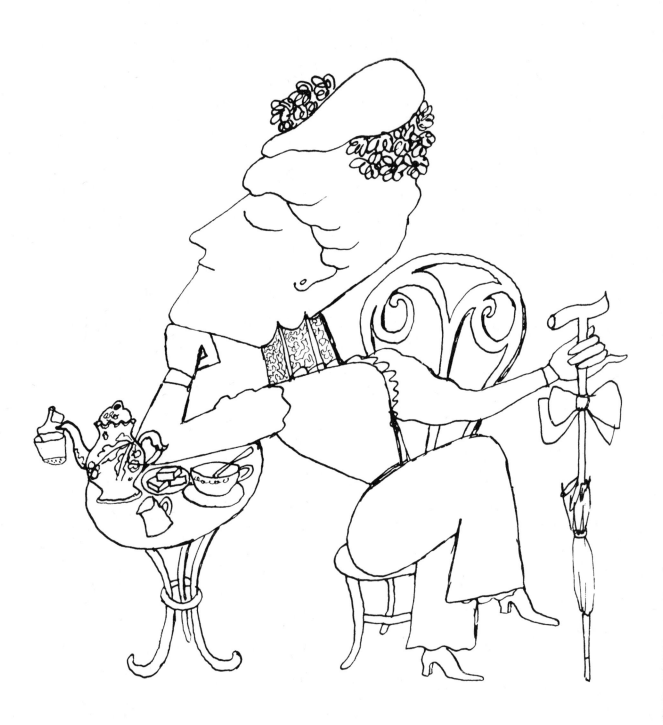

72 Self-satisfaction
Le Contentement de soi

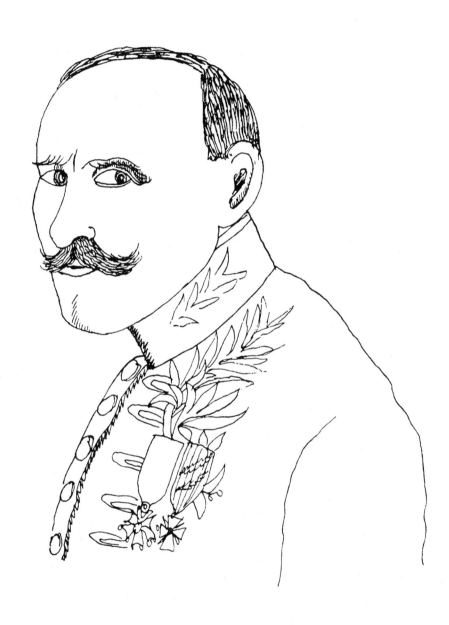

Study of a nude 73
Etude de nu

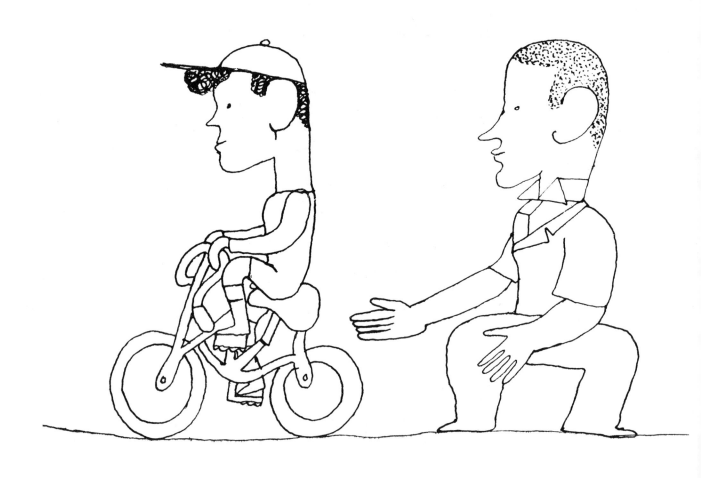

74 The bicycle lesson
La Leçon de vélocipède

Young Henry's hunt
La Chasse du jeune Henri

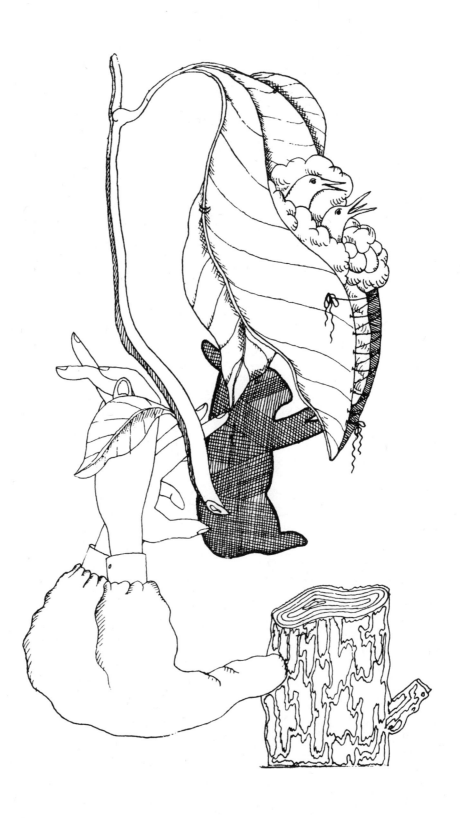

76 **The wonders of nature**
Les Merveilles de la nature

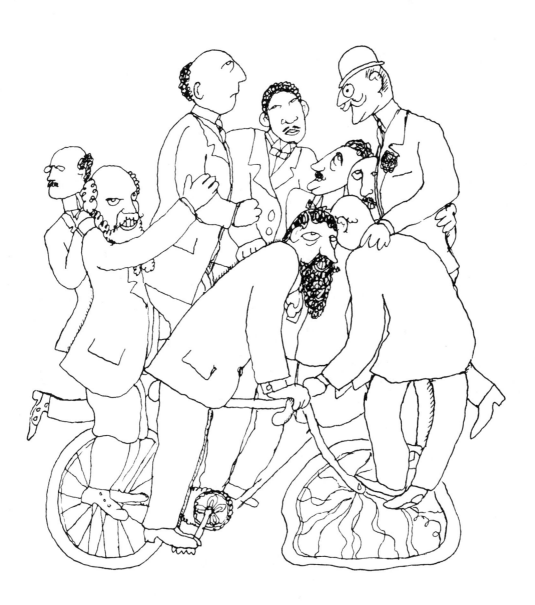

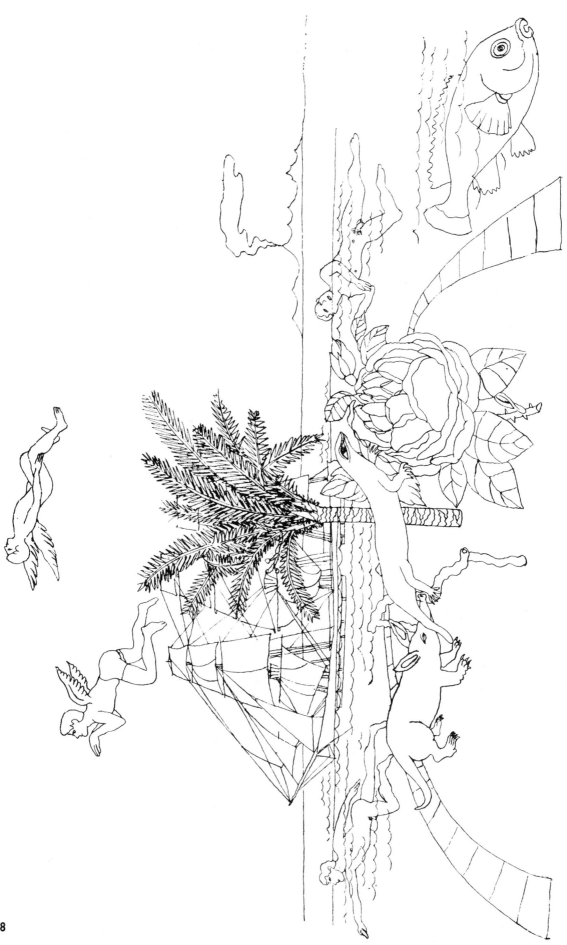

Vacation
Les Vacances

78

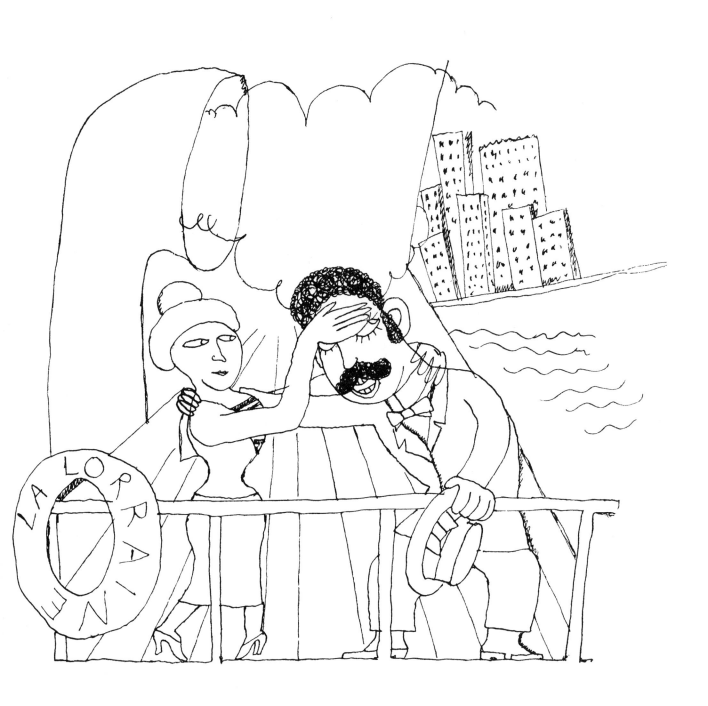

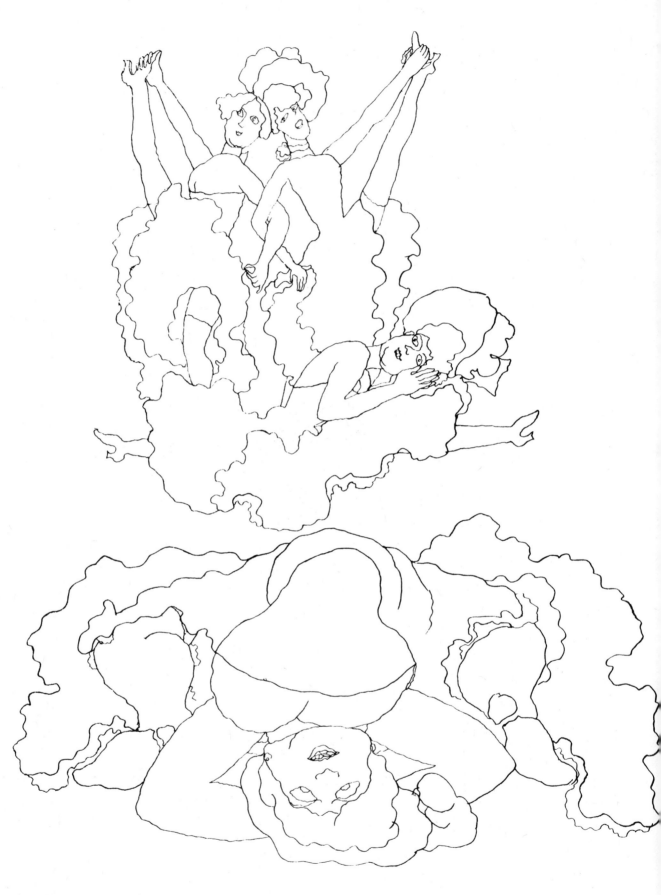

80 The split
Le grand Ecart

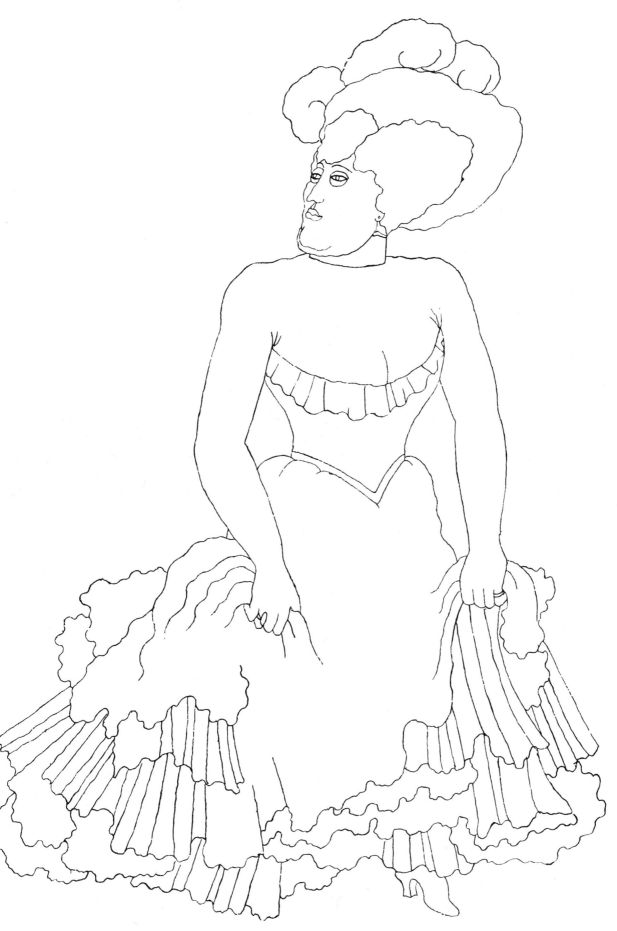

Survivor from the Golden Age 81
Survivante de l'Age d'or

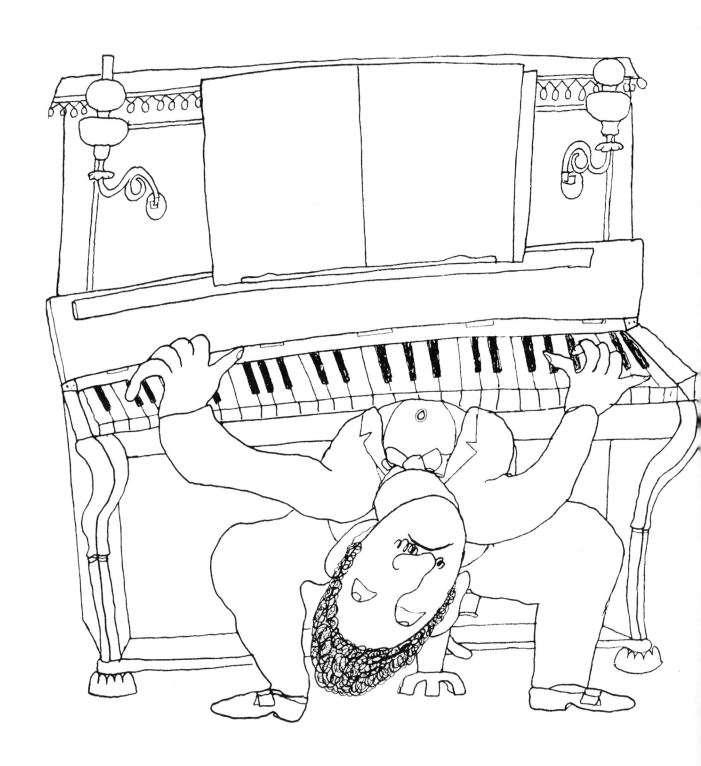

82 The expressionist
L'Expressionniste

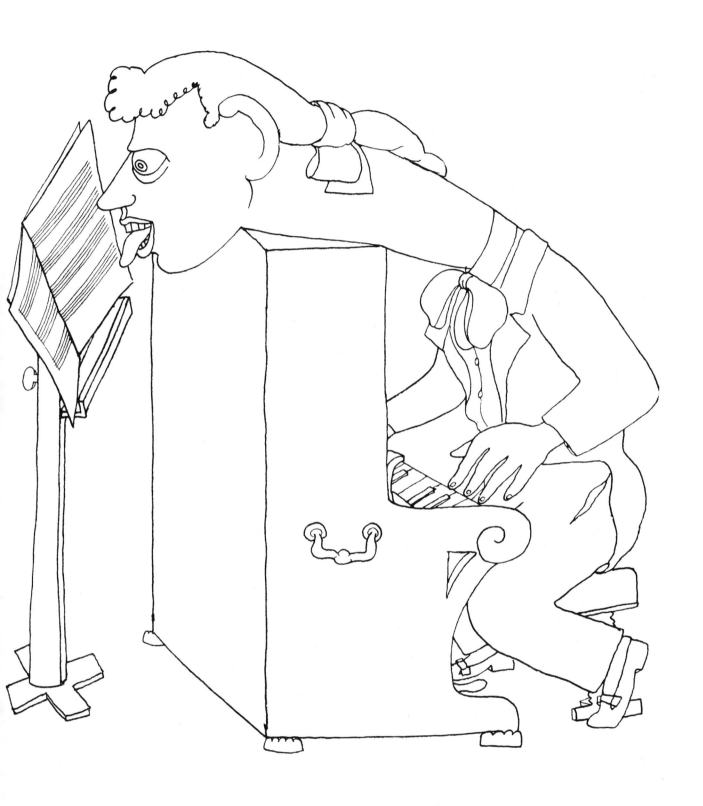

Musique de chambre

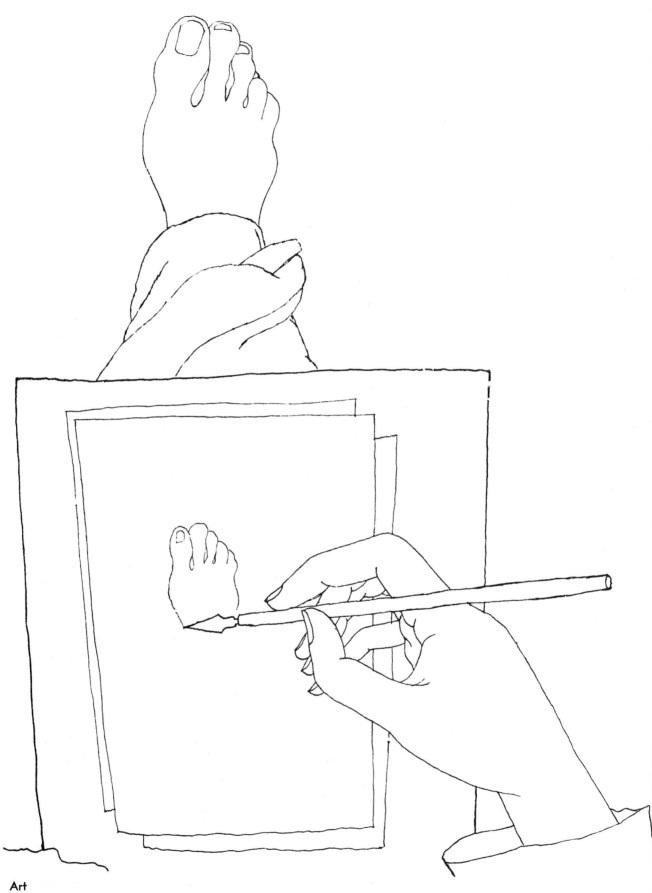

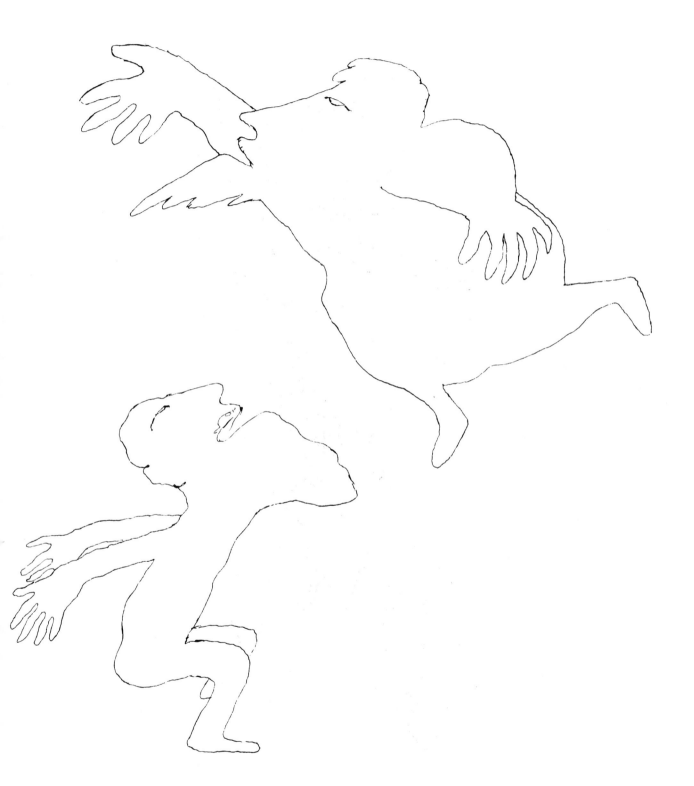

Clouds, presentiments of heaven 85
Nuages, pressentiments du ciel

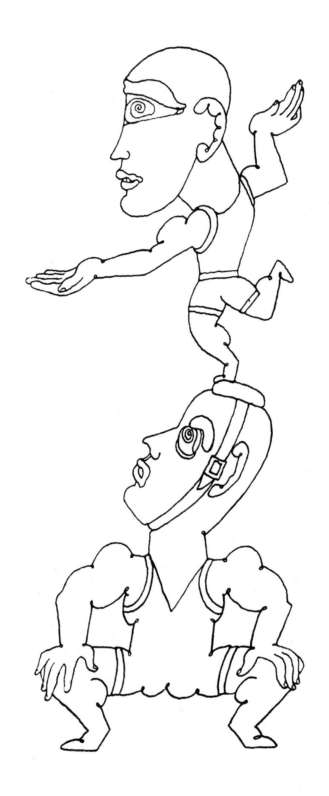

86 Cerebral love

L'Amour cérébral

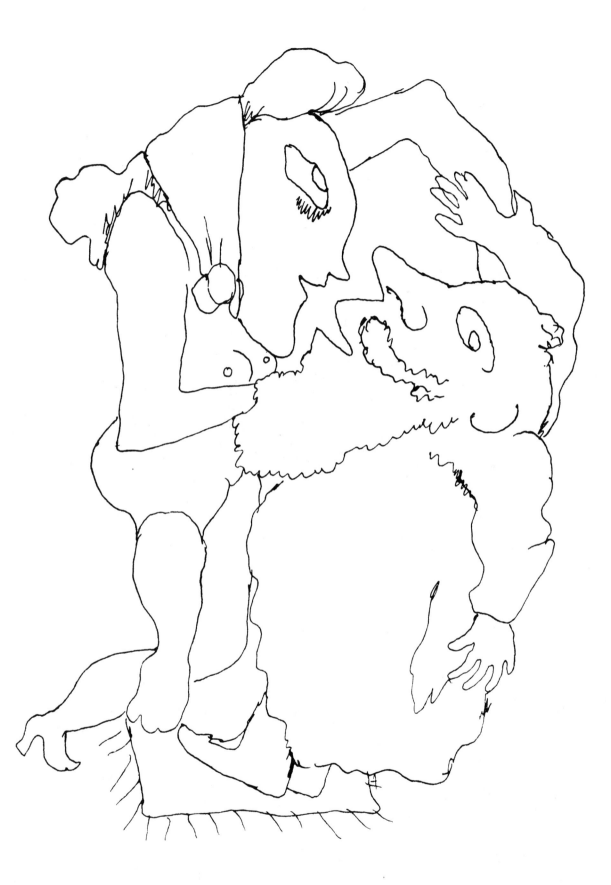

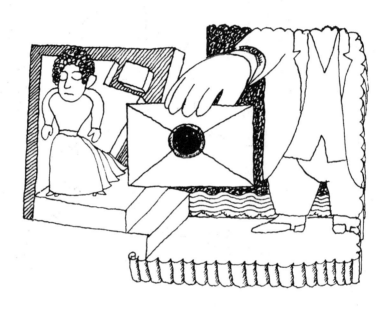

88 **Parleyers of sleep**
Parlementaires du sommeil

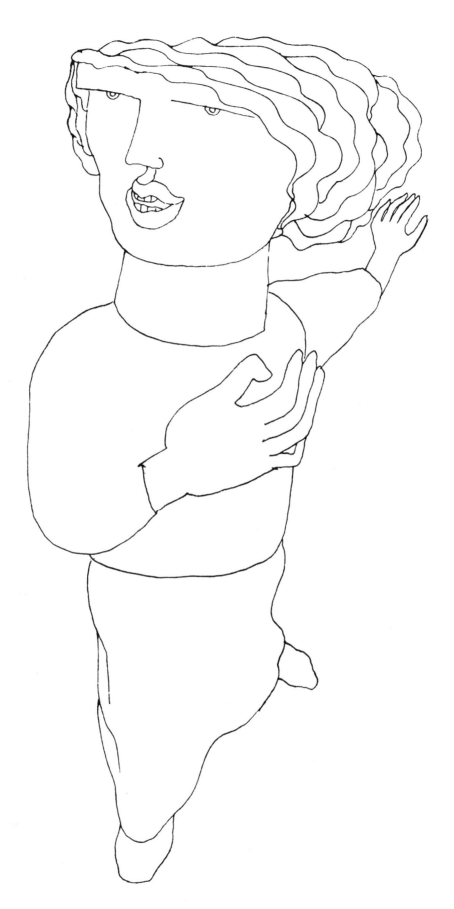

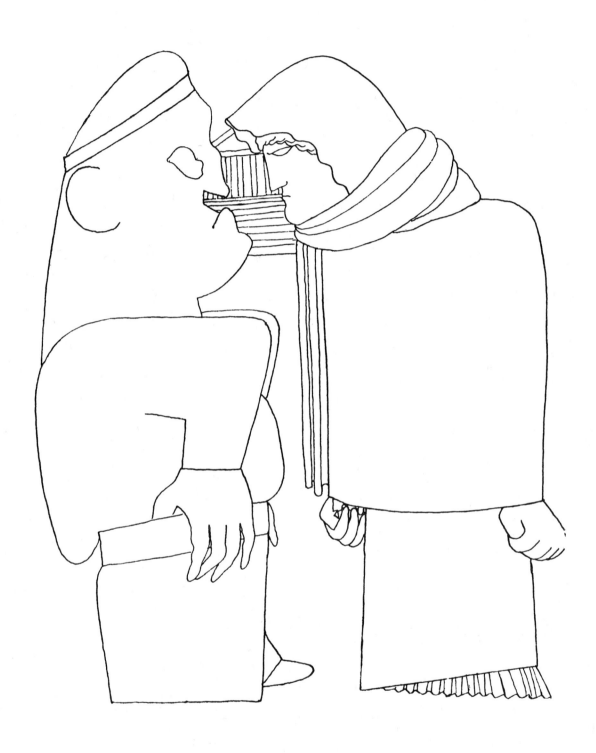

90 Antigone and Creon

Antigone et Créon

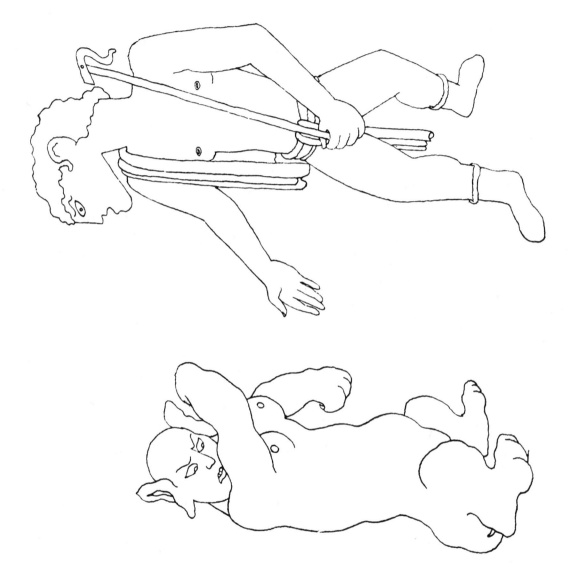

Oedipus and the Sphinx
Œdipe et le Sphinx

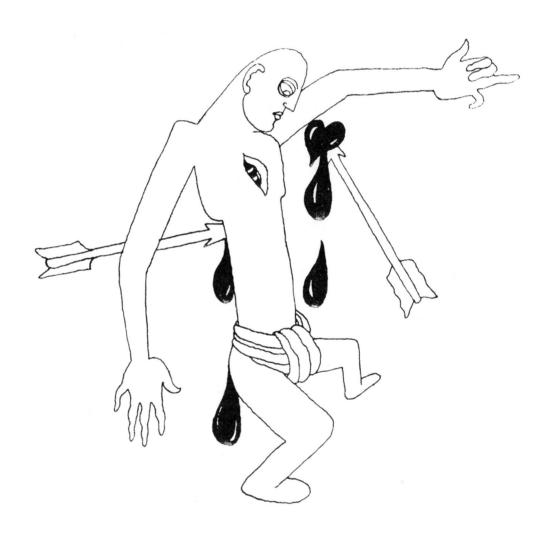

92 The jack of hearts
Le Valet de cœur

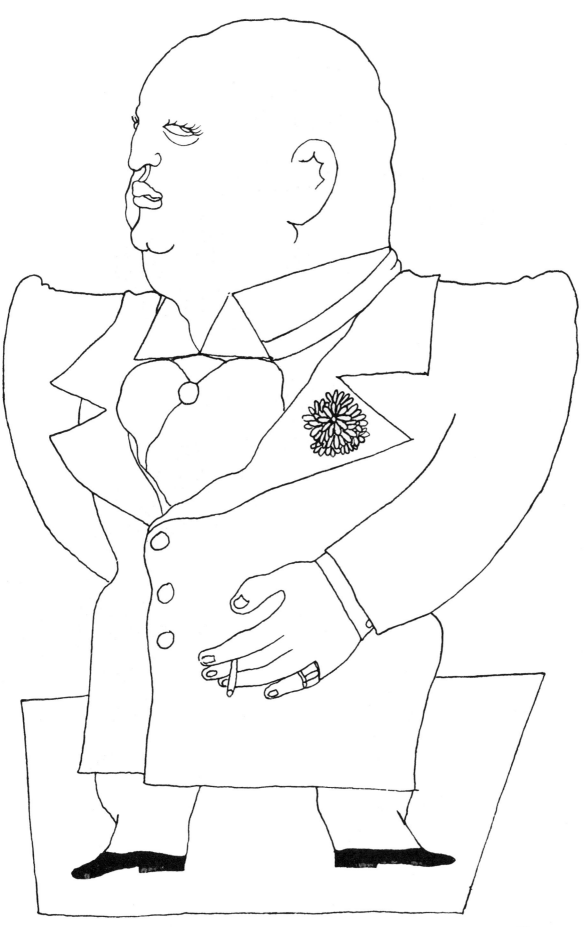

The mauve peril 93
Le Péril mauve

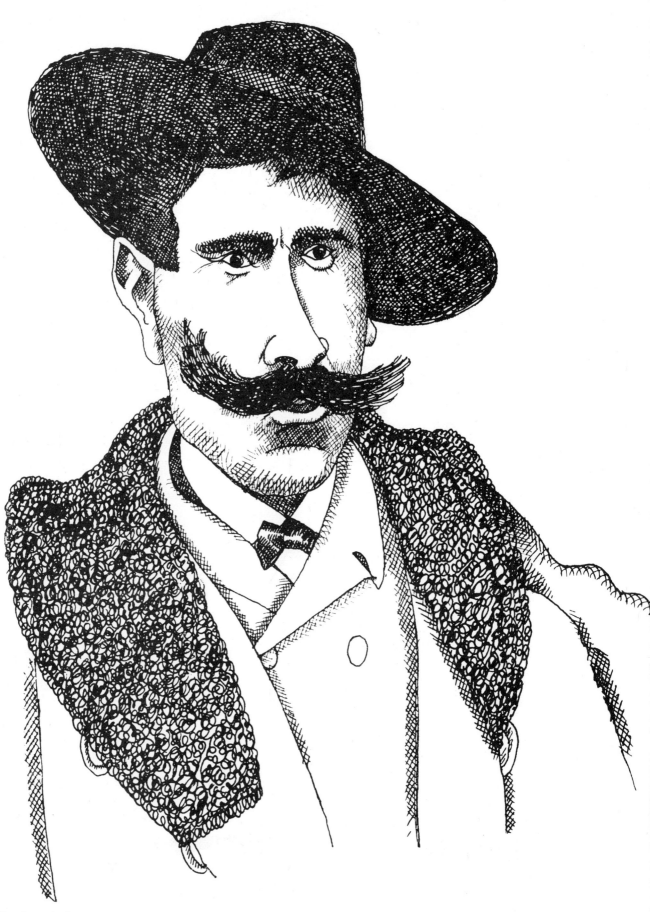

94 Psychoanalysis
La Psychanalyse

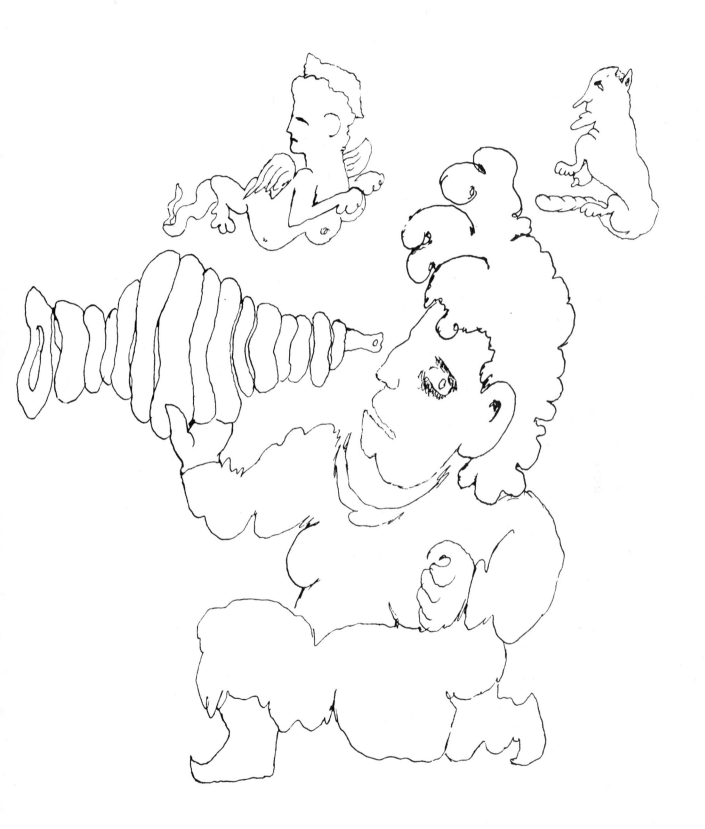

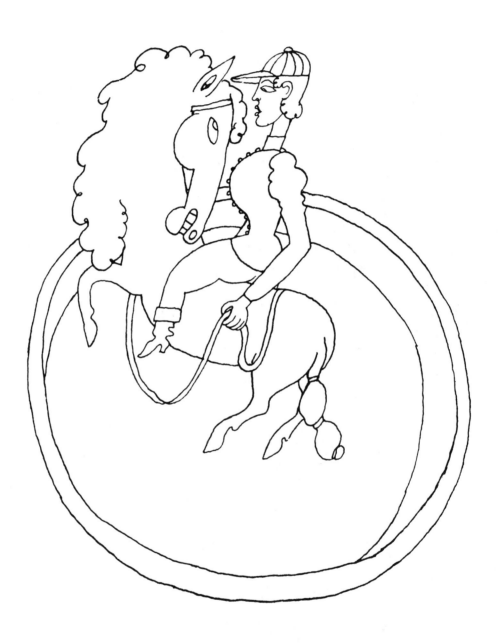

96 Human, all too human
Humain, trop humain

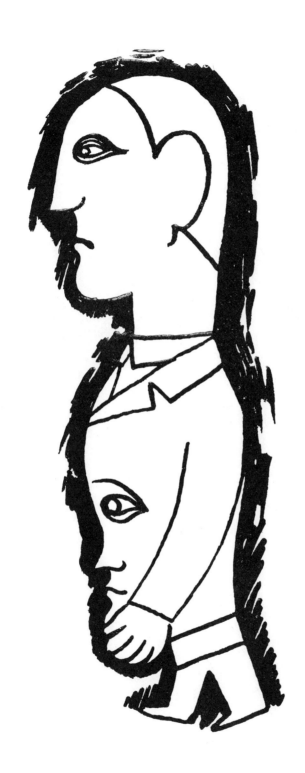

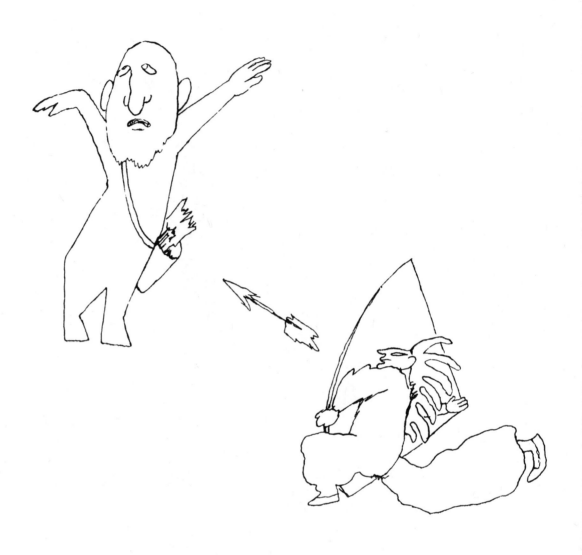

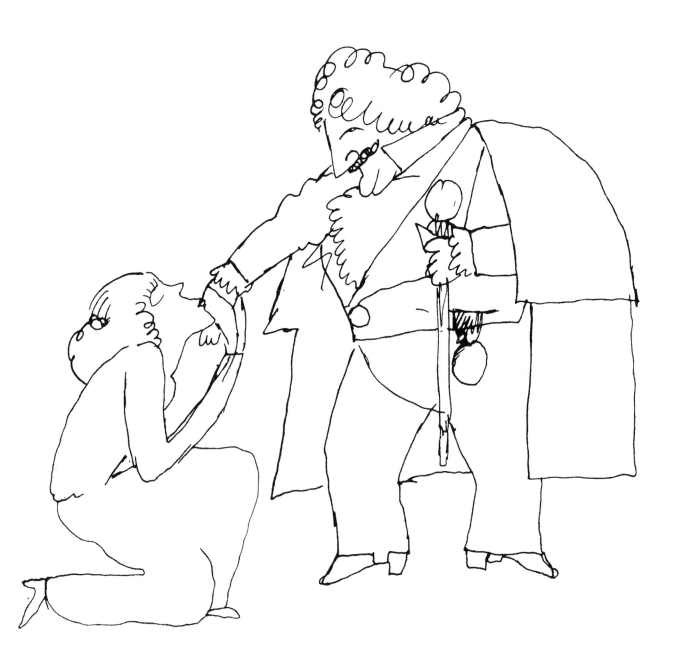

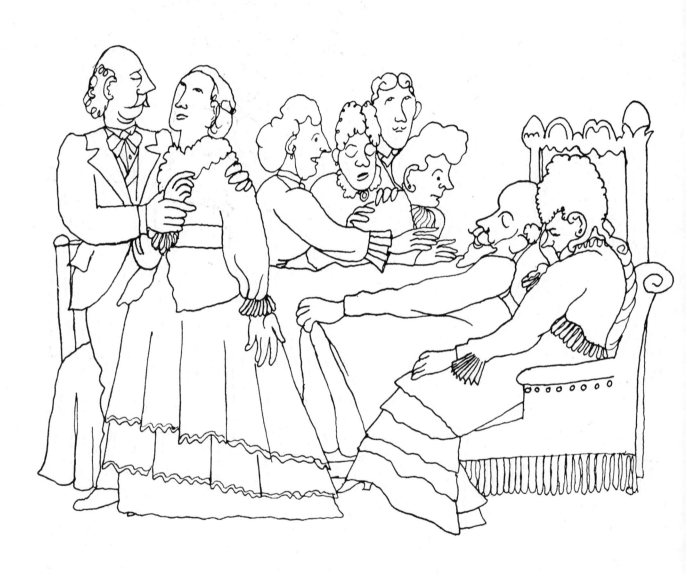

100 **Death of a famous man**
Mort d'un homme illustre

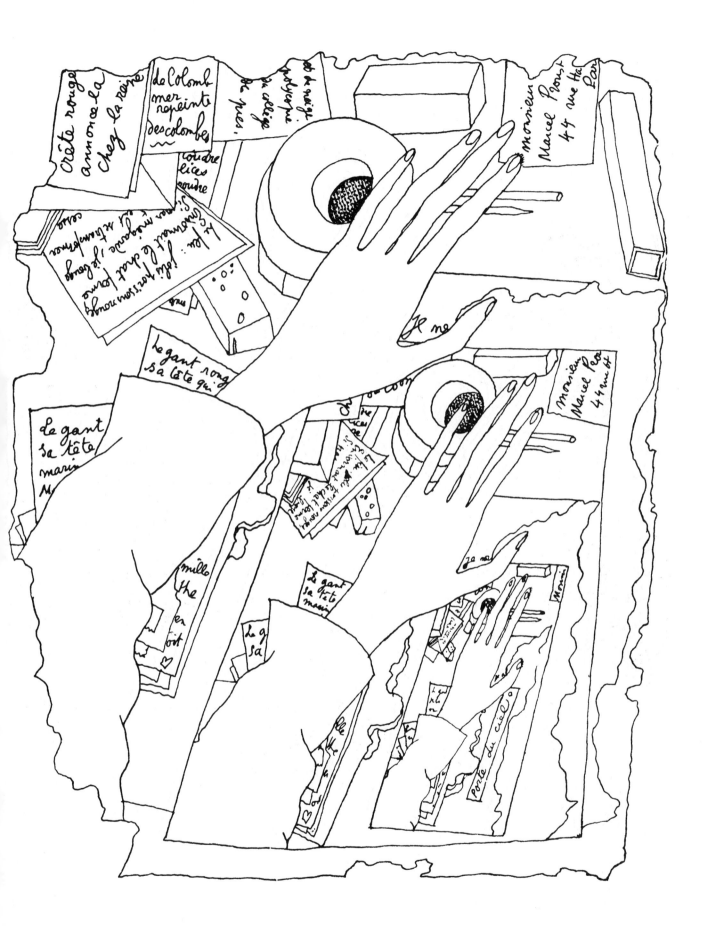

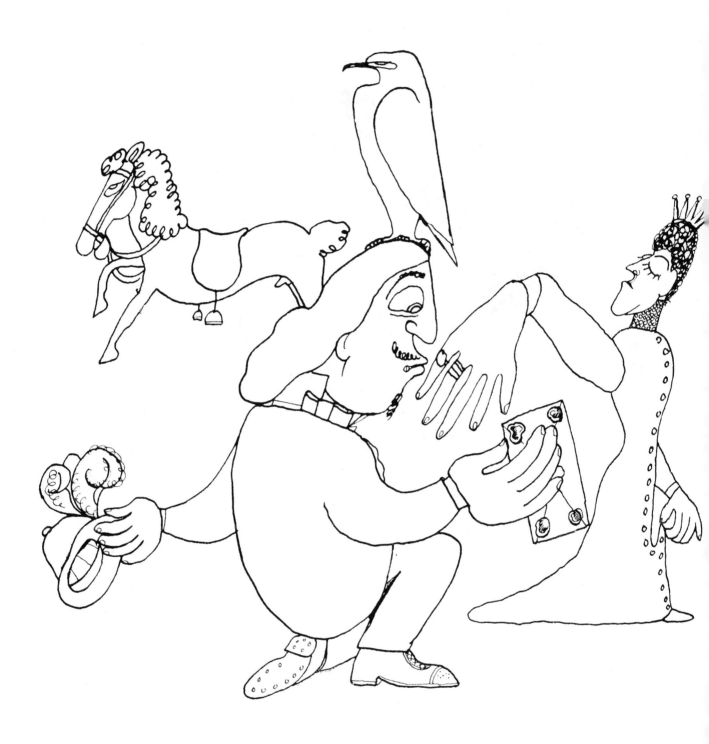

102 **The queen's courier**
Courrier de la reine

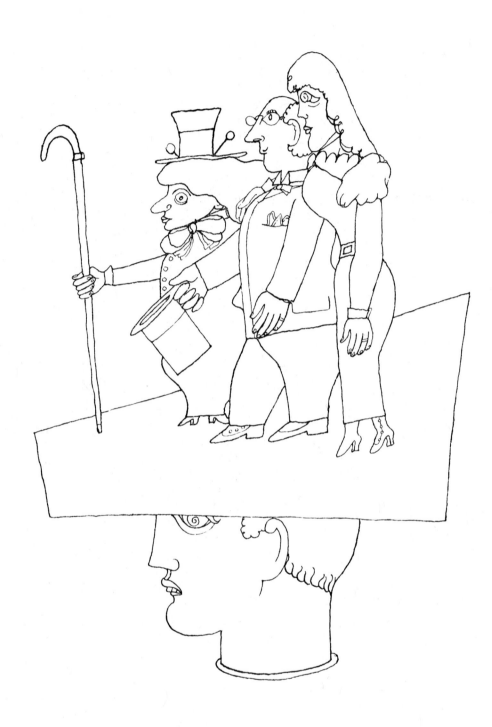

104 **The ruins of the Parthenon**

Les Ruines du Parthénon

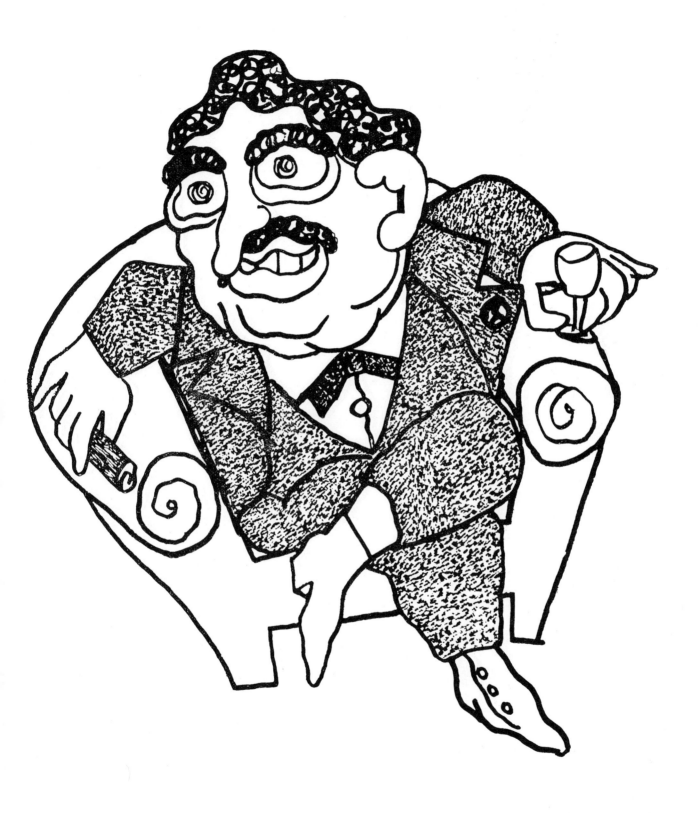

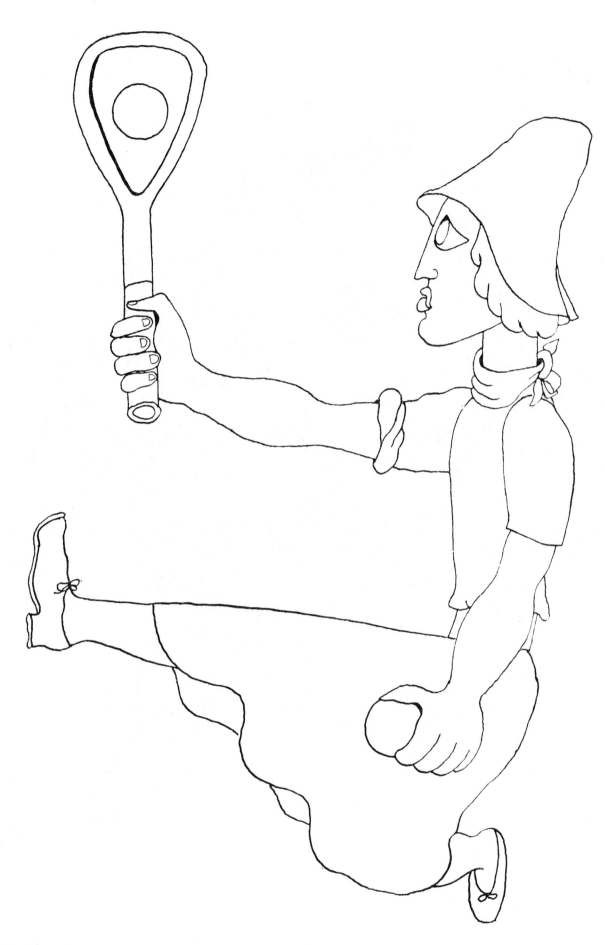

106 **The Champion**
La Championne

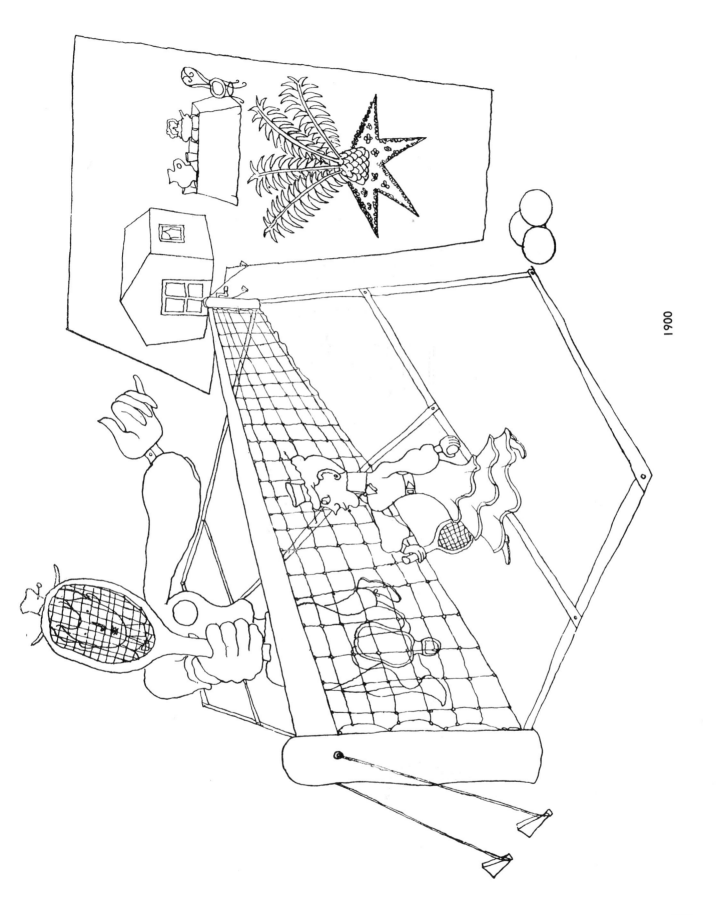

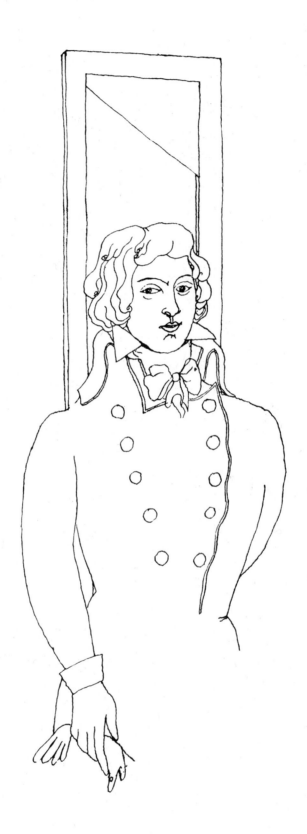

108 Saint-Just

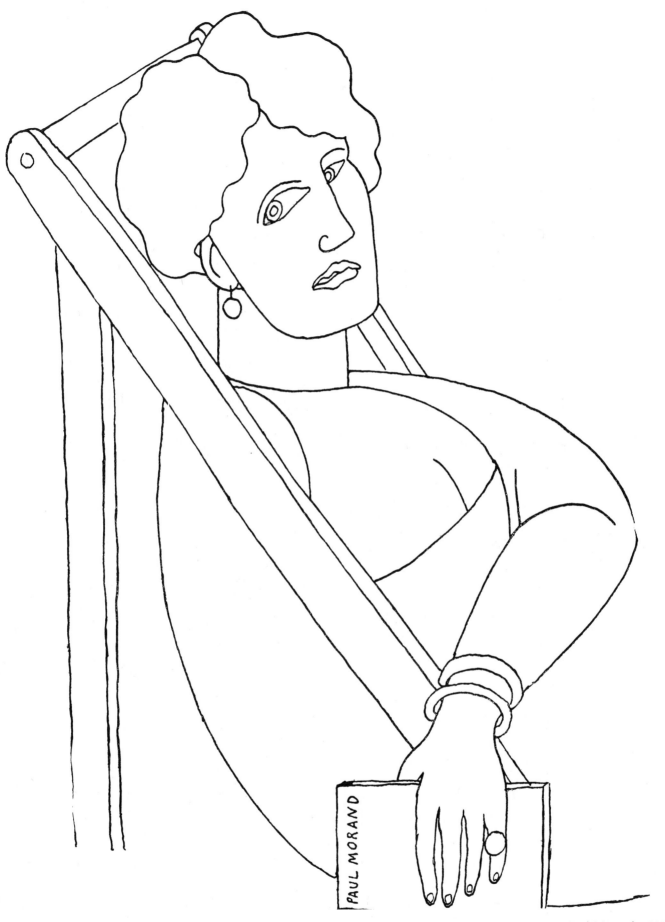

Homage to Paul Morand 109
Hommage à Paul Morand

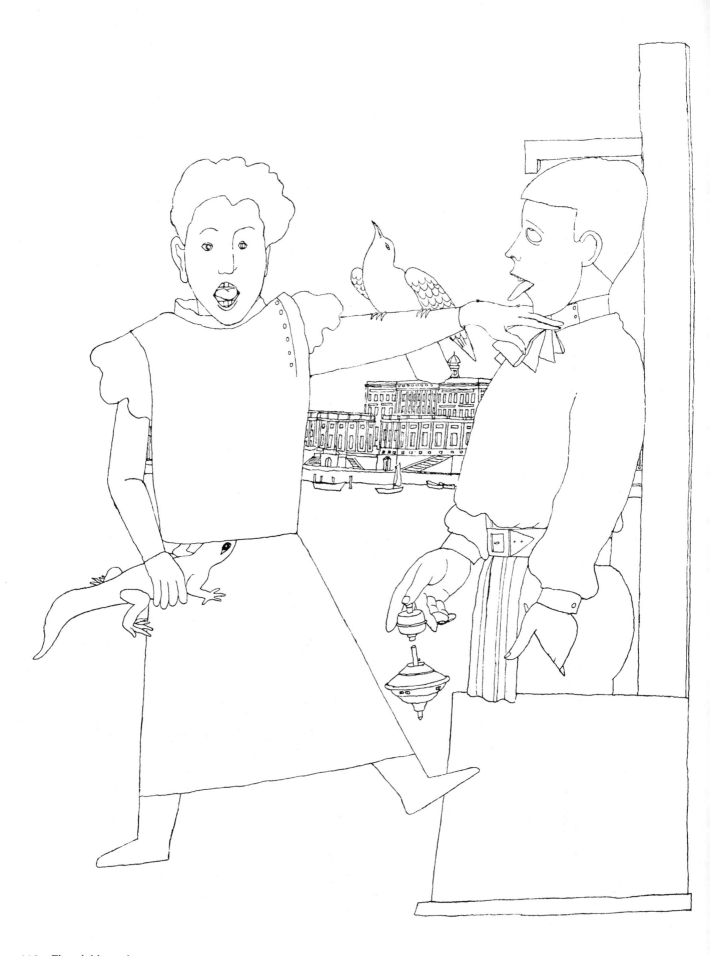

110 **The child prodigies**
Les Enfants prodiges

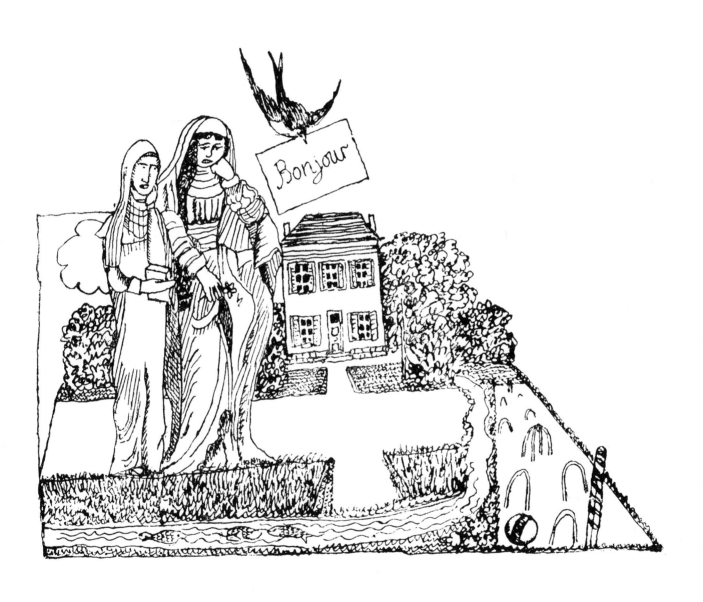

Le Jardin de Max

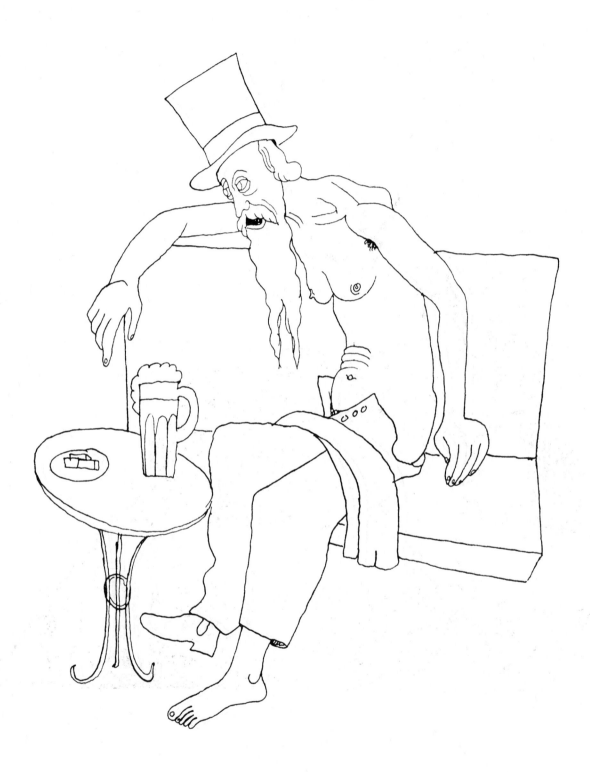

112 Literary café
Café littéraire

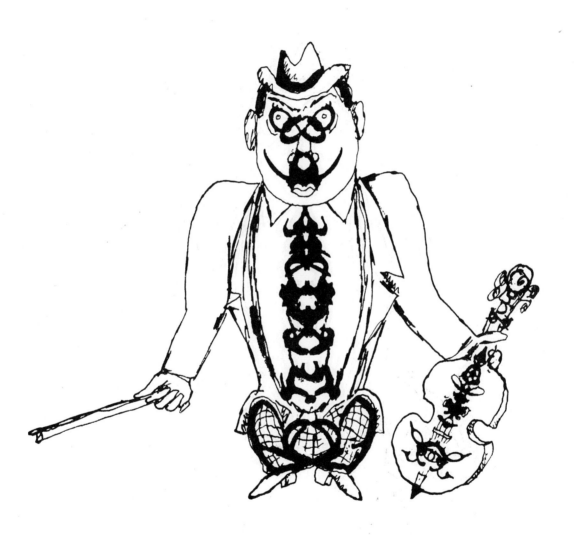

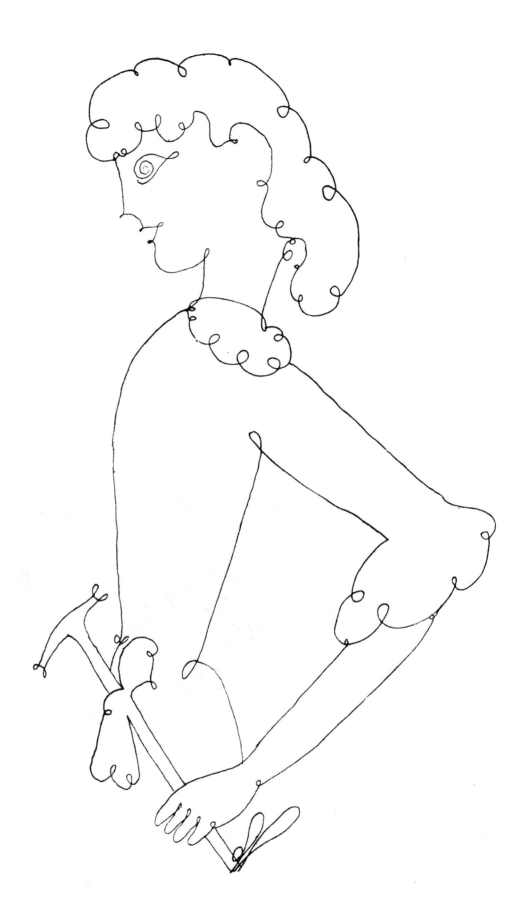

114 Girl
Jeune Fille

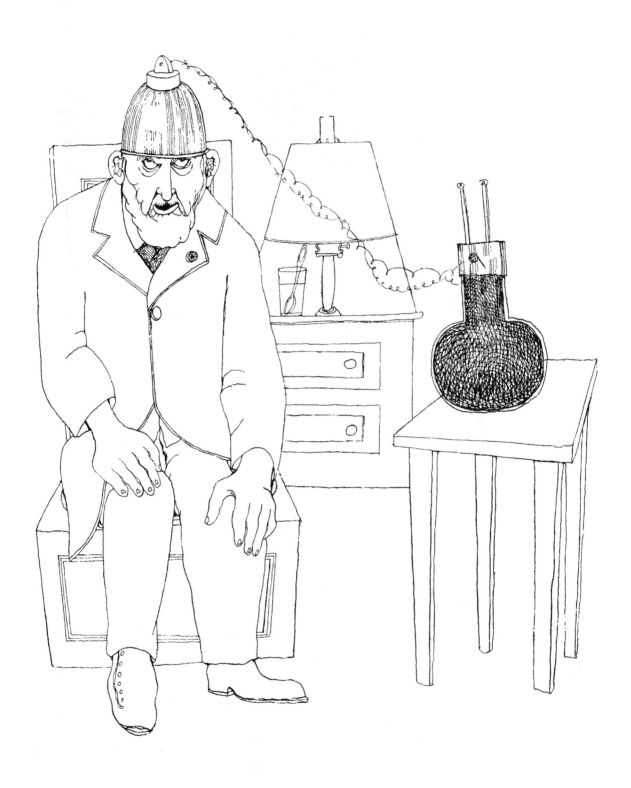

Under the dome 115
Sous la Coupole

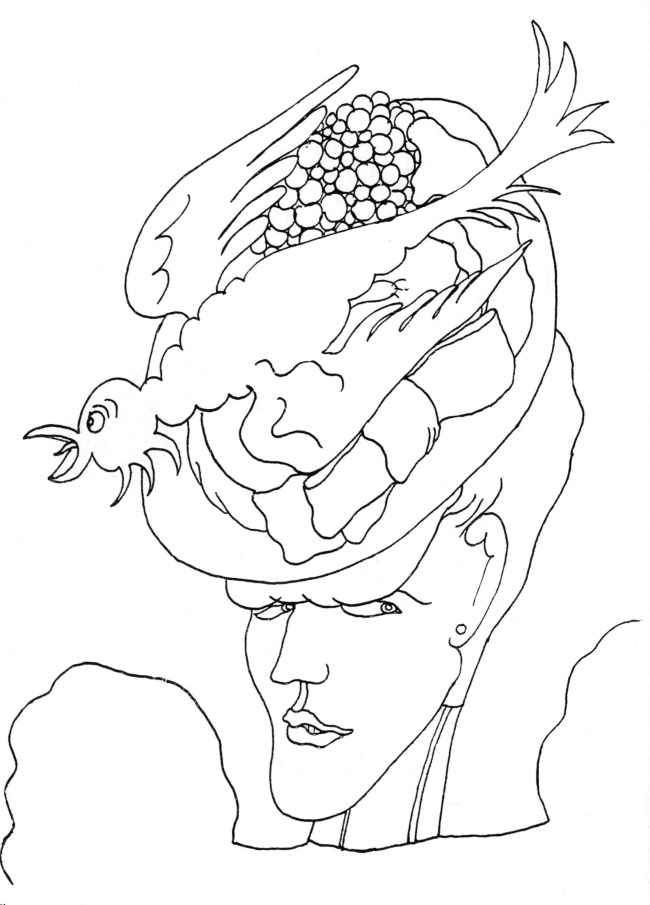

116 **The spy**
L'Espionne

Monsieur de Charlus (the false duel)
Monsieur de Charlus (Le Faux Duel)

117

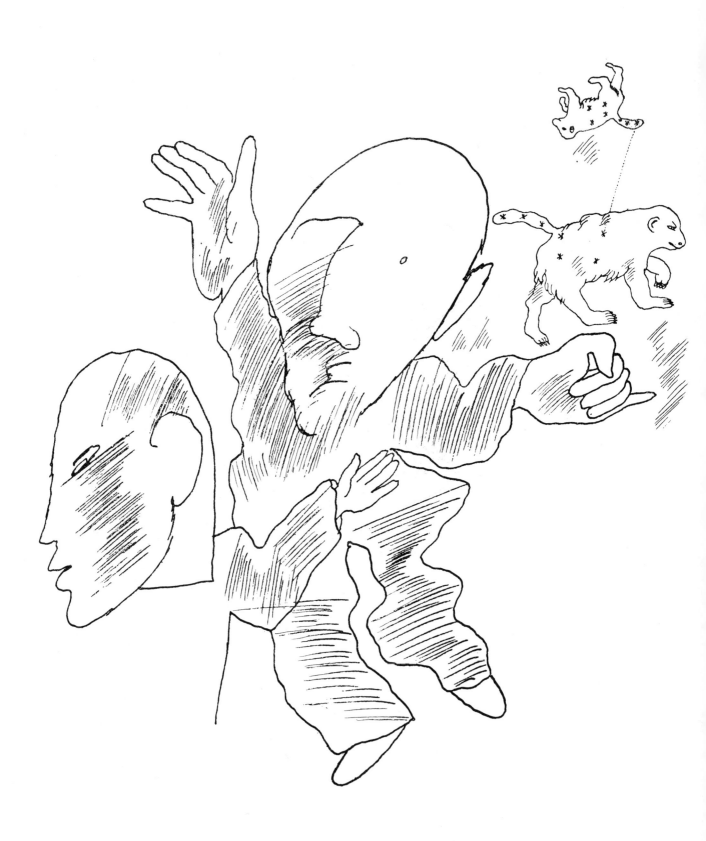

118 The song of the condemned man
Le Chant du condamné a mort

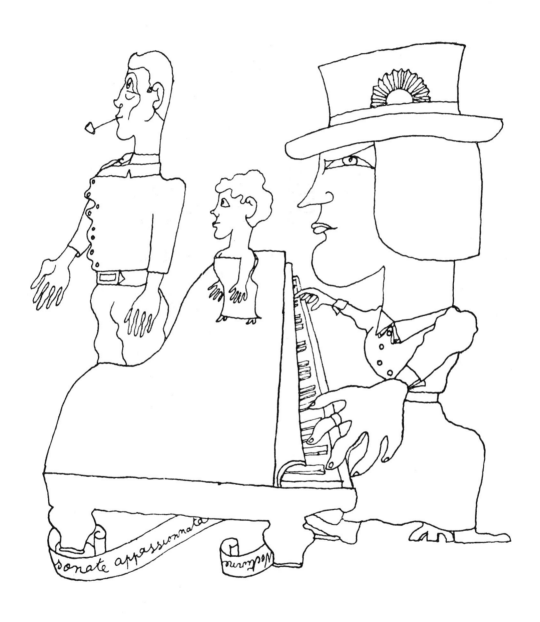

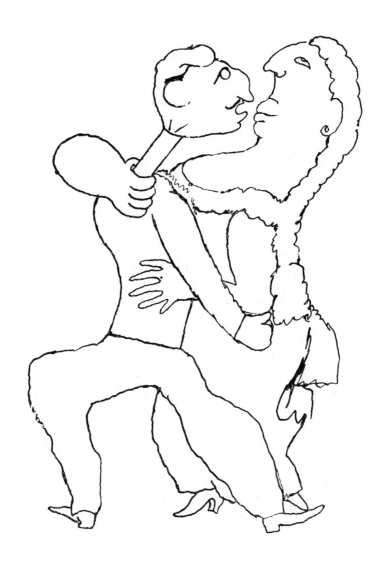

120 The senses
Les Sens

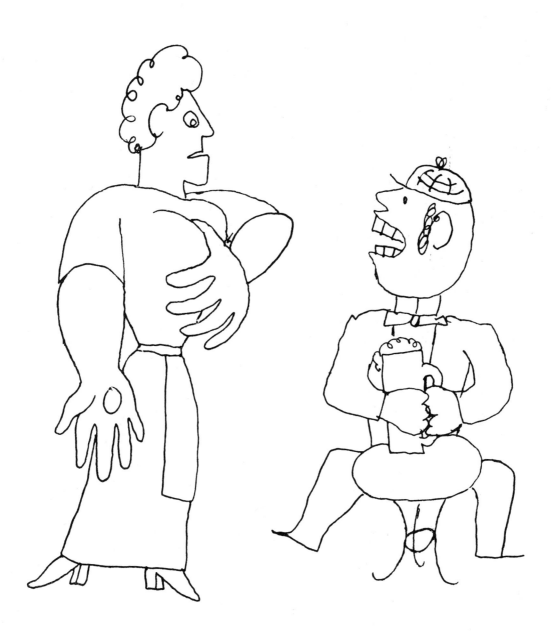

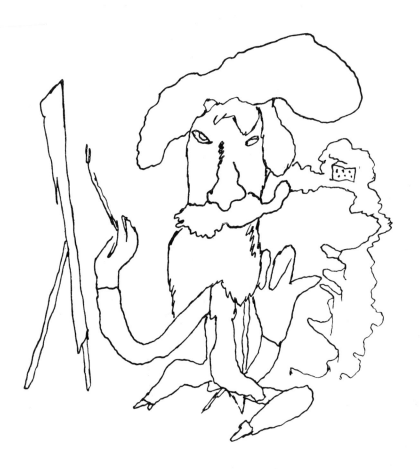

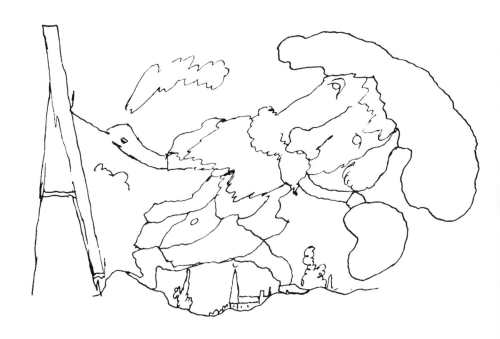

122 The Impressionist painter
Le Peintre impressionniste

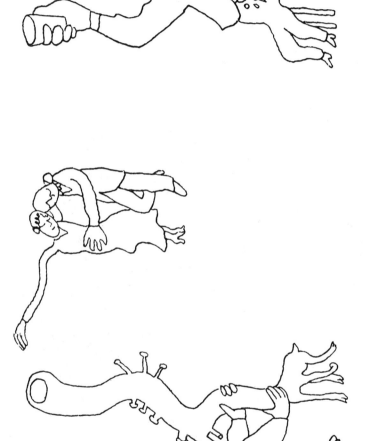

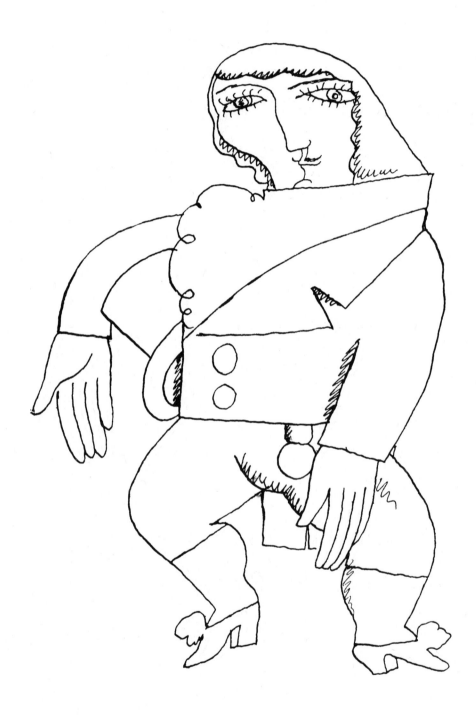

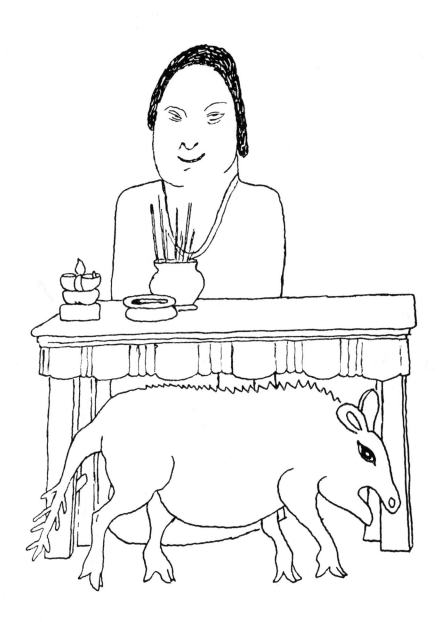

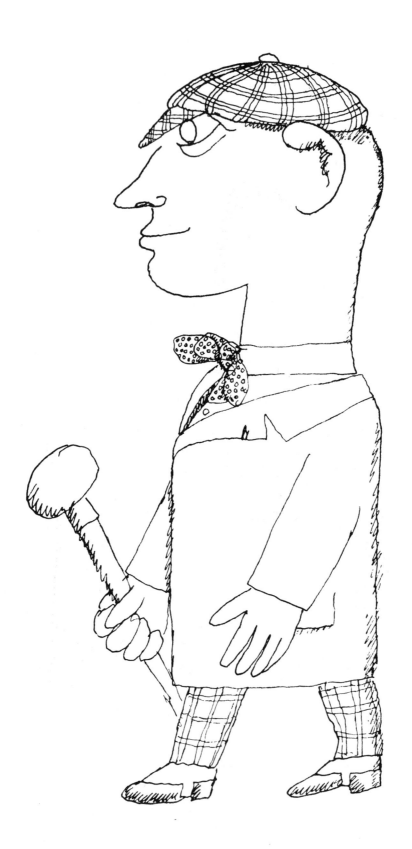

126 Around the World in Eighty Days
Le Tour du monde en quatre-vingts jours

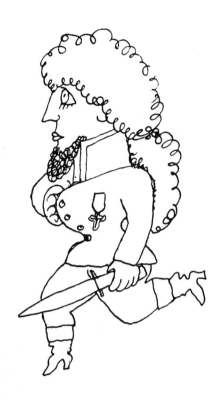

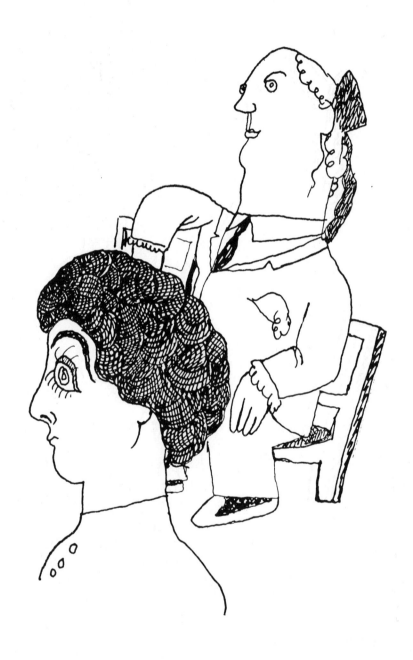

128 Saul and David
Saül et David

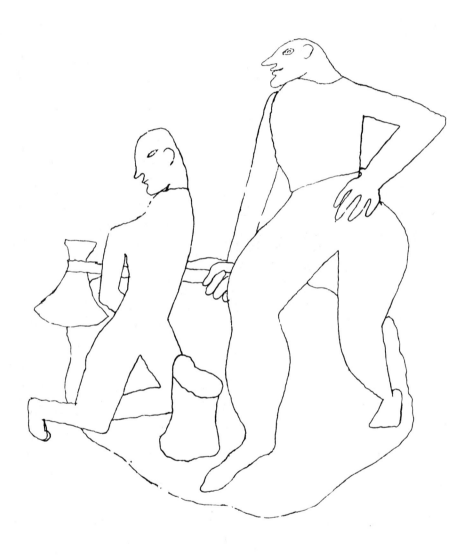

The Don Juan [literally, "executioner of hearts"] 129
Le Bourreau des cœurs